Birdlife

Also by Todd Ballantine

Tideland Treasure: The Naturalist's Guide to the Beaches and Salt Marshes of Hilton Head Island and the Atlantic Coast Coast

Birdlife

A Naturalist's Guide to Birds of the Southeast

Todd Ballantine

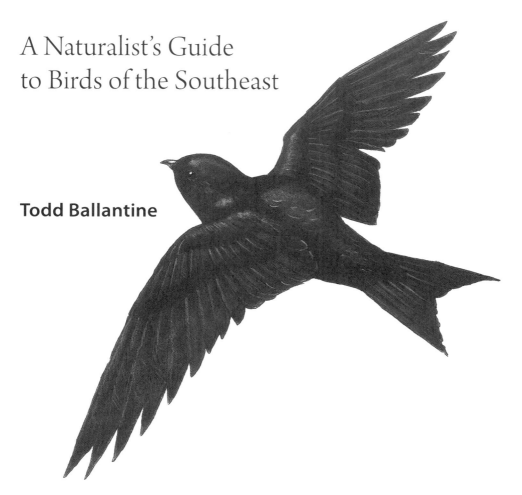

THE UNIVERSITY OF SOUTH CAROLINA PRESS

© 2022 Todd Ballantine

Published by the University of South Carolina Press
Columbia, South Carolina 29208

www.uscpress.com

Manufactured in the United States of America

31 30 29 28 27 26 25 24 23 22
10 9 8 7 6 5 4 3 2 1

Library of Congress Cataloging-in-Publication Data
can be found at http://catalog.loc.gov/.

ISBN: 978-1-64336-332-5 (paperback)

Contents

Preface ix

Fall Flocks 1

Chapter 1
Beaches, Oceans, & Estuaries

Canvasback 7
Redhead 9
Ring-necked Duck 11
Ruddy Duck 12
Red-necked Grebe 15
Horned Grebe 17
Wilson's Plover 19
Piping Plover 21
Herring Gull 22
Gull-billed Tern 24
Caspian Tern 26
Common Loon 29
Red-throated Loon 31
Double-crested Cormorant 33
Osprey 34
Ipswich Sparrow 37

Chapter 2
Marshes & Wetlands

Snow Goose 41
Canada Goose 43
Wood Duck 45
Blue-winged Teal 46
Gadwall 49
American Wigeon 50
Eurasian Wigeon 52
Mallard 54

Anatomy of a Dabbling Duck 57
American Black Duck 58
Northern Pintail 60
Green-winged Teal 62
Pied-billed Grebe 65
Common Gallinule 67
Purple Gallinule 69
American Coot 71
American Woodcock 73
Anhinga 74
Belted Kingfisher 76
Great Blue Heron 78
Great Egret 81
Tricolored Heron 82
White Ibis 84
The Rookery 87
Wading Bird Niches 89

Chapter 3
Fields & Open Areas

Mourning Dove 93
Killdeer 95
Cattle Egret 97
Turkey Vulture 98
American Kestrel 100
Eastern Kingbird 103
Tree Swallow 105
Purple Martin 107
Eastern Bluebird 109
American Pipit 110
Savannah Sparrow 113
Beaks 114
Feet 117

Chapter 4

Woods Edge, Brush, & Second Growth

Northern Flicker 121
White-eyed Vireo 123
American Robin 124
Cedar Waxwing 127
Seed Eaters 129
American Goldfinch 131
Eastern Towhee 132
Song Sparrow 135
Dark-eyed Junco 136
Yellow-breasted Chat 138
Palm Warbler 141
Prairie Warbler 143
Blue Grosbeak 145
Indigo Bunting 147

Chapter 5

Forests

Yellow-billed Cuckoo 151
Chuck-Will's-Widow 152
Swallow-tailed Kite 155
Cooper's Hawk 156
Red-bellied Woodpecker 159
Yellow-bellied Sapsucker 161
Pileated Woodpecker 163
A Bird for Every Bug 164
Eastern Wood-Pewee 166
Blue Jay 168
Tufted Titmouse 171
Brown Creeper 173
Golden-crowned Kinglet 175
Ruby-crowned Kinglet 176
Veery 179
Swainson's Thrush 181
Gray-cheeked Thrush 182

Wood Thrush 185

Evening Grosbeak 187

Purple Finch 188

Pine Siskin 190

Northern Parula 193

American Redstart 195

Summer Tanager 196

Preface

Birds are nature's most vibrant illustration of cyclical harmony. Their annual migrations knit the seasons together in a beautiful dance that has remained fluidly constant year in and year out.

When I was a student at New Trier High School in the 1960s in Winnetka, Illinois, my biology teacher challenged us to identify one hundred birds during the course of the semester. Our instructor encouraged us to identify avian shapes, habits, and habitats. I located songbirds in surrounding suburbs and forests; raptors in farmlands and sea; and shorebirds along Lake Michigan's wetlands, shorelines, and sand dunes. This was the genesis of a lifelong fascination with birds.

In 1983 I completed my book *Tideland Treasure*. The book grew out of a five-years-in-the-making graphic weekly column published by *Island Events* on Hilton Head Island, South Carolina. At the end of that run, my publisher asked me to begin work on a weekly column of southeastern birds, which has now become *Birdlife*. In 1983 my family and I moved from Hilton Head Island to Oahu, Hawaii. Continuing the same process as I did with *Tideland Treasure*, I researched, illustrated, and hand-wrote each page and sent my work for publication to *Island Events*. In the shade of the beautiful Koo'lau mountains I continued my weekly birdlife columns. Even in this Pacific paradise, my sojourn with southeastern birds kept me connected to my Atlantic sea-island home.

The text that follows includes detailed descriptions, migration, habitat, habits, and colors of some of my favorite birds I've had the pleasure of observing. The species are organized by habitat. This organization is a valuable aid for identifying birds in their natural location. Over the decades, climate change and human population growth continue to impact birds and their habitats. Information about birds' ranges and seasonal presence has therefore been updated. Many of the species in this book may also be less prevalent in some locales due to habitat loss (destruction of wetlands, forest fires, desertification, decline of water and food supply, human population intrusion). Federal and state laws continue to protect a growing list of species.

Each plate in this book, from the drawings to the lettering, has been entirely created by hand. I was trained at an early age in the art of calligraphy, and I made the decision to utilize this lettering style because every bird is a work of art, and every bird deserves a beautiful expression. You'll notice that illustrations are in black and white. I chose this approach to keep the focus on bird shapes, as most avians are at a distance or are backlit by the sun and they are more easily recognized by their silhouettes.

I hope you enjoy these illustrations as much as I've enjoyed creating them.

FALL FLOCKS

You don't have to be an expert ornithologist to notice how many birds throng to our region during autumn. Why the flurry of avian activity? There are two basic reasons. First, birds that are permanent residents are no longer nesting, so adults & juveniles alike now fly about & hunt.

BROWN PELICAN
(OCEAN, BAYS)

DUCKS
(OCEAN, INSHORE WATERS, WETLANDS)

Furthermore, migratory species stream southeast to eat insects, berries, grains & seeds, & thus add to the coastal zone's bird population. They feed voraciously to "fuel their engines" for cold weather & long flights.

COMMON CROW
(PASTURES, FIELDS, FAIRWAYS)

MOURNING DOVE
(FIELDS, ROADSIDES, YARDS, PARKS)

Watch for these familiar fall flockers when days grow brisk and leaves meld into a palette of scarlet & gold.

BOBWHITE QUAIL
(FIELDS, ROADSIDES)

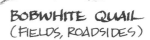

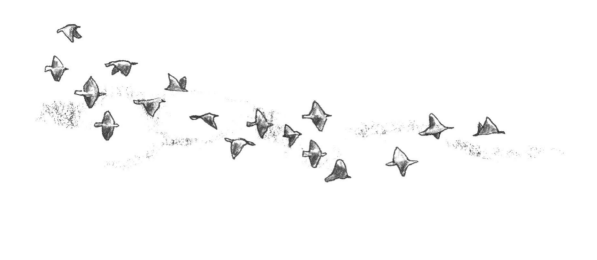

FALL FLOCKS
...CONTINUED

Here are five more common birds that will be seen traveling, feeding & at times resting together in large groups, September — December. Many of these species are well-known to Islanders. They are easiest to identify if you try to locate them in their specific habitats, shown in (parentheses).

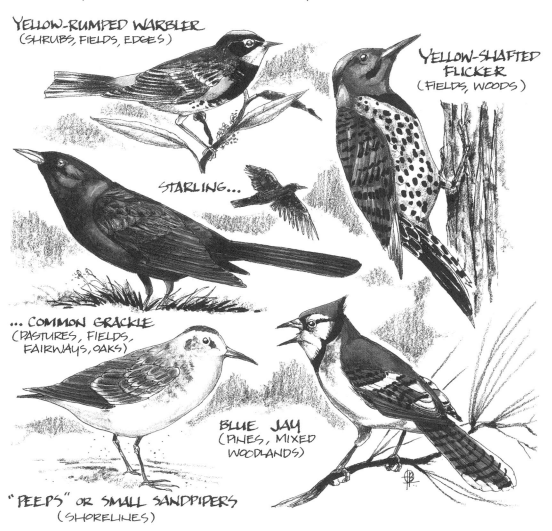

YELLOW-RUMPED WARBLER (SHRUBS, FIELDS, EDGES)

YELLOW-SHAFTED FLICKER (FIELDS, WOODS)

STARLING...

...COMMON GRACKLE (PASTURES, FIELDS, FAIRWAYS, OAKS)

BLUE JAY (PINES, MIXED WOODLANDS)

"PEEPS" OR SMALL SANDPIPERS (SHORELINES)

Chapter 1

Beaches, Oceans, & Estuaries

Aythya valisineria
Rare Winter

CANVASBACK

At first glance, the canvasback duck may look like the redhead. Identify it by its flattened forehead (redheads have round crowns). The 21" drake, shaped like a chunky mallard, displays a chestnut-red head, black breast & a "canvas-white" back & belly. More grayish hens (20") are known by their brown heads & necks.

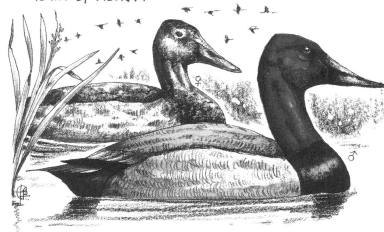

Canvasbacks are more numerous in Virginia & North Carolina than in South Carolina-Georgia. They migrate in long "V" lines that maintain a direct course. The speediest of the large ducks, they fly over 70 M.P.H. From mid-November through March, cans over-winter in estuaries, bays & nearshore lakes. These waterfowl dive to feed, & can swim many yards under water. Favored foods: Plants...pondweed, arrowhead, water lily, bulrush, alga; Animals...clams, snails, insects, crabs, worms, small fish.

Cans return again & again to the same breeding grounds... wetlands, ponds & potholes from the Dakotas & Montana through Alberta, Manitoba & the subarctics. Hens incubate 8-10 large green eggs in a nest woven from dried grass & reeds. Although the roost is nestled in thick stands of bulrush, cattails & sedge, it is still vulnerable to a host of dangers. Raccoons, skunks, crows, magpies, floods & even redhead ducks that stuff their eggs in canvasback nests are elements leading to nearly a 40% chick mortality rate. Surviving juveniles take to the northern skies at 10 weeks of age.

Aythya americana
Rare Winter

REDHEAD

The South Carolina - Georgia coast is a winter layover for just a few hundred redheads. Most migrate to the Gulf of Mexico or the Chesapeake & Palmico Sounds, North Carolina. Southern duckwatchers will spot redheads flying solo or in tight wedges less than 15 fowl strong over salt bays & creeks or fresh lakes & ponds. These birds dive to eat leaves, shoots & tubers of shoal-zone plants: widgeongrass, pondweed, water lily, naiad, rushes, sedges & algae. Small clams & snails are also consumed....

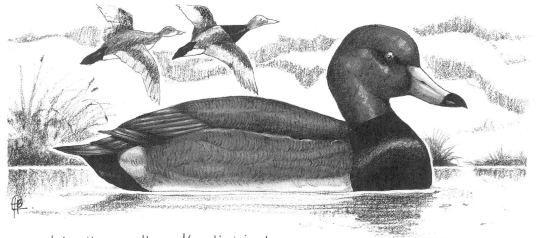

Note the redhead's distinct fieldmarks. Male: brick-red head; black breast, rump & tail; sooty-gray body. Female: dull-brown body; whitish chin patch. Both sexes: black-tipped blue bill; light gray wing patches that show in flight. This species may be confused with the larger, more common canvasback duck which has a whiter body & a flatter head.

By early March redheads mass north to breed from the Dakotas to Alberta, Canada. In or near marshes & pothole sloughs these "pochard" ducks build nests of dead rush & cattail stems lined with down. Normally 7-10 eggs are brooded. But parasitic females deposit eggs in the clutches of other redheads as well as canvasbacks, mallards, teal & scaup. Due to such ovum-overcrowding, over 1/3 of redhead chicks annually die unincubated in the shell.

BEACHES, OCEANS, & ESTUARIES

Aythya collaris
Common Winter

RING-NECKED DUCK

Small, tight flocks of swift-winged ring-necked ducks invade the southern coast by November, peaking in population by Christmas. Secretive waterfowl, they prefer secluded bottom-land ponds, timbered lakes, rivers; or salt creeks & bays. Here ring-necks dive the shoals, hunting tubers, roots, stalks, leaves & seeds of aquatic plants. Minnows, crawfish, snails & tadpoles comprise about 10% of their duck-diet.

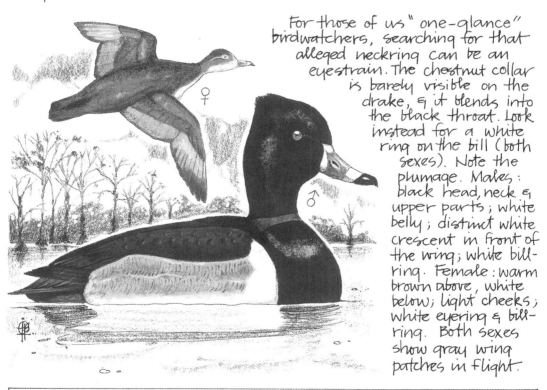

For those of us "one-glance" birdwatchers, searching for that alleged neckring can be an eyestrain. The chestnut collar is barely visible on the drake, & it blends into the black throat. Look instead for a white ring on the bill (both sexes). Note the plumage. Males: black head, neck & upper parts; white belly; distinct white crescent in front of the wing; white bill-ring. Female: warm brown above, white below; light cheeks; white eyering & bill-ring. Both sexes show gray wing patches in flight.

March skies fill with ring-necks migrating north to breed. They travel in single-file, "traincar" formation. Most will build nests in marshes in the Mackenzie District, northern Alberta, Saskatchewan & Manitoba, Canada. Dead vegetation & down homes float like rafts or are lodged in reedy, shrubbed hummocks. The 6-12 grayish-buff eggs hatch July-August.

BEACHES, OCEANS, & ESTUARIES

Oxyura jamaicensis
Winter

RUDDY DUCK

This duck's common name only fits the drake in reddish, spring–summer nuptial plumage. During winter the stocky "butterball" bird is most noticed by its black cap, white cheeks (streaked with dark on the hen), and a bristled tail which it fans stiffly upwards. Spring males hold their tails erectly to attract nestmates. Underparts are gray; undertail coverts, white. Size: 15 up to 16 in.

Approximately seventy-seven percent of all ruddies overwintering on the East Coast migrate to the coastal zone between the Chesapeake Bay and the Savannah River, in Georgia, November through March. Brackish estuaries, saltwater bays, fresh ponds, lakes, and even excavated ditches are favorite habitats. Here in 2- to 10-ft. depths, the birds dive to eat seeds, tubers, and leaves of pondweed, widgeon grass, muskgrass, wild celery, and bulrush. Snails and clams are hunted where plants are scarce. Agile swimmers, these ducks silently sink or plop below the surface when danger nears. Rarely will they fly to escape predators.

Ruddy ducks breed in the prairie sloughs and on shores from the Dakotas and Montana to Alberta and Manitoba, Canada. They heap dry grass, rushes, and reeds together, making a floating cradle for nine to fourteen cream-buff eggs. Flash flooding is the biggest threat to the brood of tiny "bristletails."

RUDDY DUCK

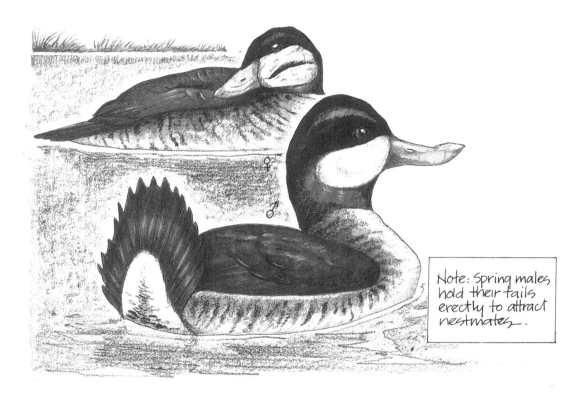

Note: Spring males hold their tails erectly to attract nestmates.

Podiceps grisegena
Accidental

RED-NECKED GREBE

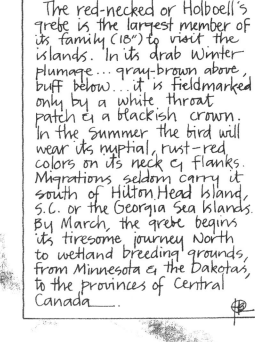

The red-necked or Holboell's grebe is the largest member of its family (18") to visit the islands. In its drab winter plumage... gray-brown above, buff below... it is fieldmarked only by a white throat patch & a blackish crown. In the summer the bird will wear its nuptial, rust-red colors on its neck & flanks. Migrations seldom carry it south of Hilton Head Island, S.C. or the Georgia Sea Islands. By March, the grebe begins its tiresome journey North to wetland breeding grounds, from Minnesota & the Dakotas, to the provinces of Central Canada___.

A solitary swimmer, the red-necked grebe is seen diving for dinner in Atlantic or marshside waters. Its large bill enables it to snare more sizeable fish, snails, shrimp & crabs. Birdwatchers will be amused by its clumsy attempts to take to the air. This weak-winged grebe will skitter across the surface in a froth of flapping feathers & mad-paddling feet. Laboring upwards, the bird shows white wing patches___.

BEACHES, OCEANS, & ESTUARIES

Podiceps auritus
Winter

HORNED GREBE

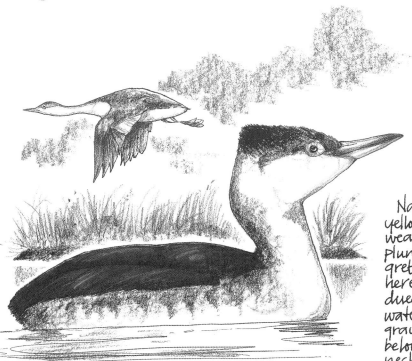

Named for the yellow ear tufts it wears as summer plumage, the horned grebe overwinters here in more subdued colors. The 14" waterbird is dark gray above, whitish below. Its white neck & face are capped with a black crown. Unlike its relative, the pied-billed grebe, the horned grebe will frequent coastal waters (sounds & estuarine creeks) rather than lagoons or ponds. Hunters & old-time birders know this superb swimmer as "water witch", for its uncanny ability to vanish underwater, leaving scarcely a ripple or trail of bubbles. Its strong, lobed feet propel it deep on dives, when feeding upon fish, insects, mollusks, or small crustaceans. In flight, the horned grebe is recognized by its stubby tail, fast-flapping wings & sagging neck.

BEACHES, OCEANS, & ESTUARIES

Charadrius wilsonia
Summer

WILSON'S PLOVER

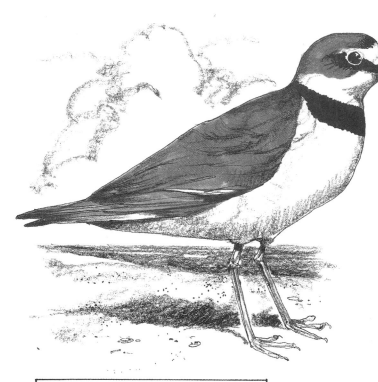

The Wilson's plover is easily identified from kindred plovers by its broad, black breast band, its white eye stripe & its stout black bill. Plumage is snow white below, brownish-gray above. This retiring shorebird may be viewed on quiet, open beaches, tideflats or offshore sandbars. It feeds along the water line, using its short, pigeon-like bill to peck small crustaceans, mollusks & marine worms from the surface. At your approach, the fleeing Wilsons will whistle a single-noted, "wheet!", in alarm.

A scraped-out cavity of sand is this plover's humble attempt at nest building. Here are laid 3 grayish-green eggs which are speckled to blend with grains, shell bits & pebbles. Wilson's plovers overwinter from southern Florida to the West Indies.

BEACHES, OCEANS, & ESTUARIES

Charadrius melodus
Winter

PIPING PLOVER

This 7" winter visitor wears the camouflage colors of its sandflat habitat. The piping plover appears chamois-gray above, snowy-white below. By November, its broken black neckring has faded to gray, & its black-tipped, yellow bill has darkened noticeably. Legs are goldish. A nervous feeder, the plover scurries the strand in starts & stops, peck-hunting clams, small crustaceans, worms & maggots. Dining is interrupted by inwashing waves. This bird must flee the approaching sea because like all plovers, its feet lack the rear, 4th toe needed for balance in wet sand. Note: this shorebird is named for its sweet, piping whistle.

Piping plovers migrate to the Chesapeake Bay & north to Newfoundland to breed in spring. 4 speckled, clay-toned eggs are roosted in sand hollows, lined with shells, pebbles & wood bits.

BEACHES, OCEANS, & ESTUARIES 21

Larus Argentatus
Common

HERRING GULL

From Florida's Everglades to the bouldered Maine coast, this shorebird is simply called "seagull." The herring gull's colors are easily remembered. Its cool-gray mantle is highlighted by white-spotted black wing tips. The head, underparts, and tail are snow white. Focus your field glasses on the yellow beak with a faint red spot and the pale-pink legs. Overwintering adults are streaked and dull-billed. Immature gulls (under two years old) are dirty brown.

A well-traveled wingster, the herring gull shows its hungry face in every near-shore habitat. The Atlantic, riverbanks, lakes, marinas, even refuse dumps . . . here this "water vulture" can always scrounge a meal. Small fish (live or dead) are the main entrée. Other foods include clams which it snatches with its feet and breaks open by dropping them on rock piles or pavement; small crustaceans; birds and their eggs; insects; a salad of plant matter strewn in flotsam and trash. Watch for this gull soaring overhead, bobbing offshore swells or leaning into the breeze at ebb tide.

Herring gulls breed in rookeries from the North Carolina coast northward. Nests are built on the ground (a bare hollow). Dark splotches camouflage three pale-blue to deep-olive eggs. In the colony's close quarters, many youngsters are head-pecked to death by irascible old-timer gulls.

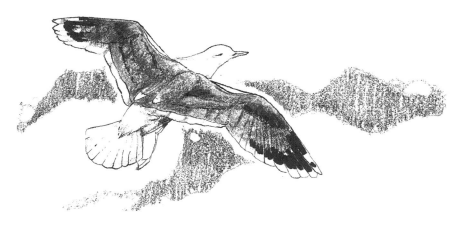

HERRING GULL

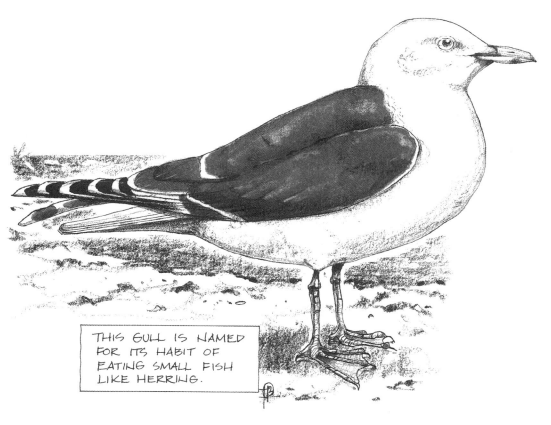

THIS GULL IS NAMED FOR ITS HABIT OF EATING SMALL FISH LIKE HERRING.

Gelochelidon nilotica
Summer

GULL-BILLED TERN

In comparison, this bird noses out the other forty-nine species of terns. It is unique for its stout black beak, slightly curved at the tip, which is more similar to a gull's bill. With its oversized proboscis, the gull-billed tern has developed habits not shared by its cousins. It "hawks," or feeds, by swooping with its mouth agape for insects and spiders in marshes and fields. Most other tern species plunge into the sea for fish. During nesting season, the gull-billed tern dive-bombs and pecks intruders. Most terns take to the skies.

Apart from its namesake beak, the pure white gull-billed tern is known by its greenish-black crown (summer only) and black feet. Its wings are broad and short and its tail slightly notched. Size: up to 14 in.

Gull-billed terns nest most commonly in the Gulf states and throughout Florida, yet the birds may go as far north as the Chesapeake Bay to breed. Their three olive-buff eggs, blotched with earthen hues, are laid in a depression of sand or marsh greens. Winter homes: from Southern Mexico to South America.

GULL-BILLED TERN

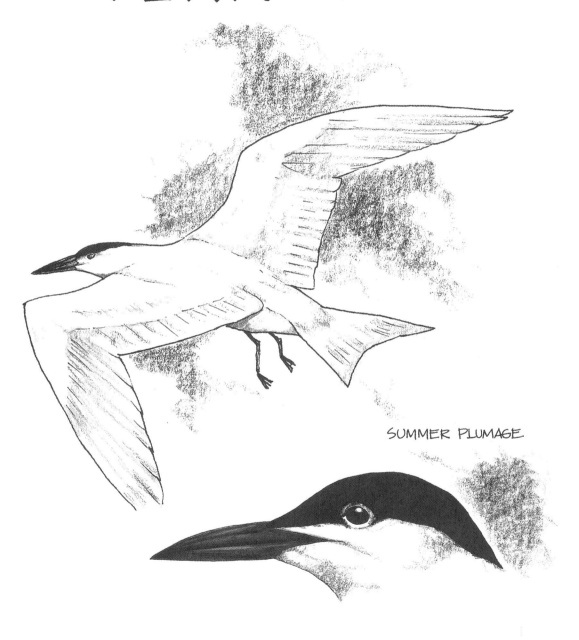

SUMMER PLUMAGE

Hydroprogne caspia
Common Permanent

CASPIAN TERN

The imperial member of the tern sub-family is the Caspian. Nearly gull-sized, it measures 19 up to 23 in. in length. Its bright plumage—a snow-white underbody, black cap, flame-red bill—and a barely forked tail stand out at a hundred-yard distance. And in the every-bird-for-itself world of the sea, this tern is a fierce predator.

Watch for the Caspian soaring with beak pointed down above the ocean, estuaries, and inland lakes from the mid-Atlantic coast to the Gulf of Mexico. Screaming, "kraar!" like a battle-cry, it nosedives into the water to strike small fish, shrimp, squid, and crabs. When pelicans feed nearby, the Caspian tern will pluck fish right out of their roomy throat pouches. This bird also raids other birds' eggs.

Gregarious Caspian terns breed in rookeries (colonies) with kindred terns, gulls, and pelicans. Hundreds nest wing-to-wing on secluded sand bars and flats. Three olive-tan eggs are laid in a scuffed-out hollow. Brown and lavender spots camouflage the clutch into its grainy environment. Downy hatchlings soon learn where home is in their seaside suburb. Any chick that blunders into the wrong nest will be pecked to death by protective neighbor terns.

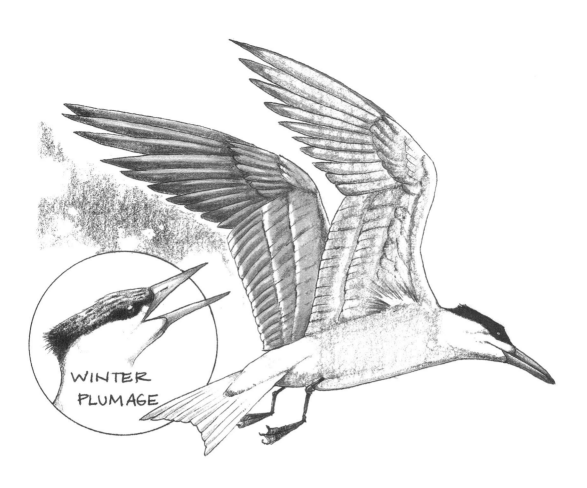

CASPIAN TERN

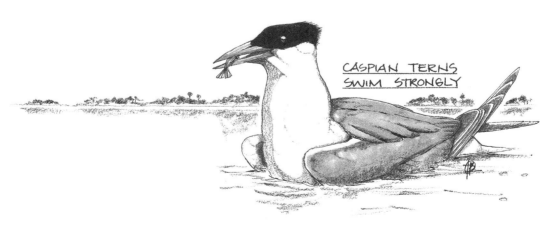

Gavia immer
Common Winter

COMMON LOON

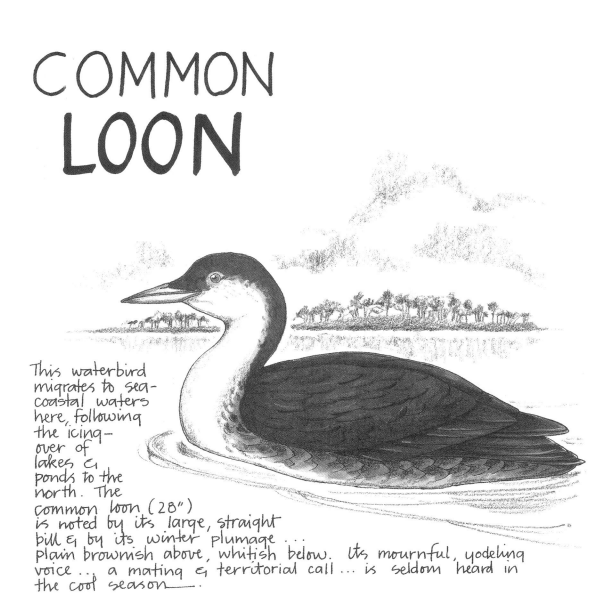

This waterbird migrates to sea-coastal waters here, following the icing-over of lakes & ponds to the north. The common loon (28") is noted by its large, straight bill & by its winter plumage... plain brownish above, whitish below. Its mournful, yodeling voice... a mating & territorial call... is seldom heard in the cool season.

A solitary swimmer, the loon is seen far offshore, diving for fish, crabs & mollusks. Strong legs & big, webbed feet are placed near the rump for rear propulsion. When the loon dives, it rides up on the surface, then swiftly dips below. Flapping its wings underwater, the saltwater submariner achieves great speeds. Takeoff is more awkward. To raise its 10 lb. body aloft, the loon runs along the surface, while madly thrashing its wings. Strong seabreezes give lift. In flight, the loon holds its head lower than its body. Wingbeats are fast & steady. These traits distinguish the common loon from cormorants, ducks or grebes.

BEACHES, OCEANS, & ESTUARIES 29

Gavia stellata
Winter

RED-THROATED LOON

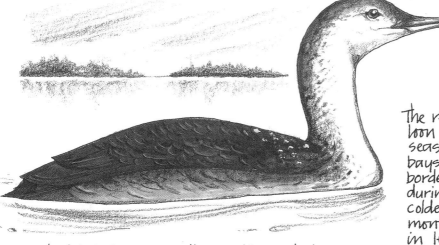

The red-throated loon swims the seas, sounds, bays & estuaries bordering our isles during the coldest winter months. 25 in. in length, the waterbird is a smaller, slimmed-down version of the common loon. It is brownish-gray with white speckling on top, & white on its chin & underbody. The little loon typically holds its slender bill upwards when swimming. Do not look for its namesake, red throat now. When the bird prepared for autumn migration, this nuptial flag was lost in molting.

Typical of its family, the red-throat is a superb diver & undersea swimmer. Small fish, crabs, shrimp, clams & snails are snared during lengthy, deep-water plunges. By early spring, this loon wings to the Hudson Bay — Newfoundland zone to nest. In flocking flight, it sags its neck & raises its long wings high. 2, earth-toned eggs are brooded on the tundra banks of small lakes or ponds.

BEACHES, OCEANS, & ESTUARIES 31

Phalacrocorax auritus
Common Winter

DOUBLE-CRESTED
CORMORANT

Ragged "V" formations moving in silhouette against darkening skies highlight cormorants moving south for the winter. These glossy, blue-black birds inhabit inshore bays, coastal waters, rivers & larger lakes. Most commonly, they will be observed flying inches above the wave tops, with a fast-flapping motion reminiscent of ducks. At perch upon power lines or channel markers, 35" Cormorants reveal lengthy, hooked bills & orange throat pouches. Their name-sake, double crest of crown feathers, is only seen during the breeding season.

So skillful are cormorants at catching fish & eels, they are nicknamed, "shag". Their bodies are efficient diving machines. They pull themselves undersea with their wings, while paddling their lobed feet & steering with their stiff tails. Their feathers lack an oily cover-ing (this normally would provide buoyancy) which allows the birds to dive up to 100 feet deep! Following the plunge, their plumage is actually waterlogged. As a remedy, cormorants typically spread wings apart in the breeze until they "blow-dry".
f. Ballentine.

BEACHES, OCEANS, & ESTUARIES 33

Pandion haliaetus
Permanent

OSPREY

Roughly translated from Latin, osprey means "bone breaker." The name fits. This fish hawk hovers on fast-flapping wings, then dives feet-first into the sea, inshore waters, or rivers to capture finny prey. Menhaden, mullet, catfish, and even bass are killed instantly by the stab of long talons. Barbed pads on the feet keep quarry from slipping loose. The catch is always carried head-forward to cut down on in-flight wind resistance.

Measuring up to two ft. long with a 5½-ft. wingspan, the osprey is commonly confused with eagles for its size. But its field marks are distinct: head and under-parts are white; a broad-black band stripes the face and nape; upper parts are brown; wings are spread at a "V" angle.

Osprey mates erect bulky platforms of branches, seaweed, and debris atop cypress trees or utility poles and return each year to the same nest. This solitary lookout allows the keen-eyed raptors to spot approaching egg-predators (crows, vultures) or enemy eagles. Three buff-brown chicks first fly at eight weeks. Ospreys overwinter from Florida to the Gulf states.

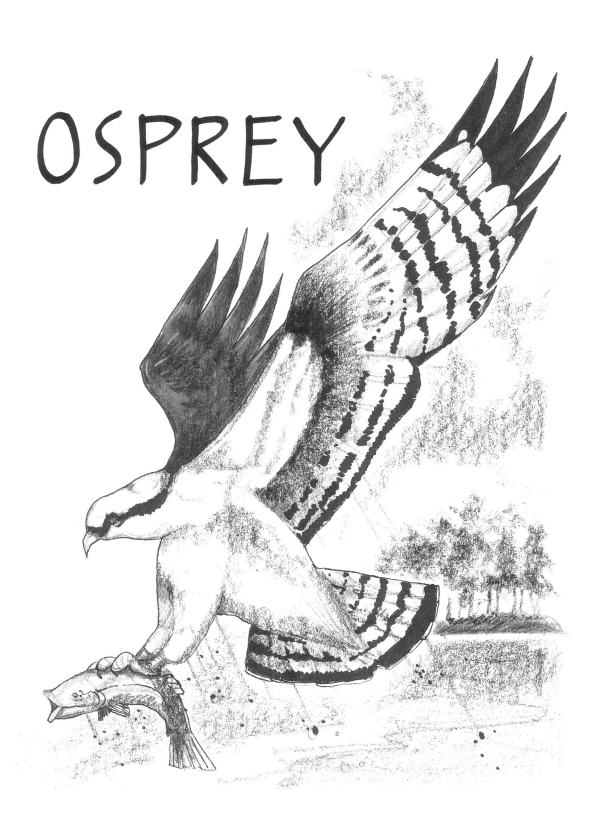

BEACHES, OCEANS, & ESTUARIES

Passerculus sandwichensis princeps
Rare Winter

IPSWICH SPARROW

The Ipswich sparrow is a subspecies of the savannah sparrow that overwinters in the sand dunes & billowing grasses guarding beachfronts from Cape Cod to Cumberland Is., Ga. Here it eats the windstrewn seeds of American beachgrass, panic grass, dock, knotweed & lambsquarters. The bird is a rare find along the East Coast because it seeks only the fragile oceanfront niche which is shrinking under the pressure of real estate development.
 When flushed by your footsteps, the timid Ipswich flies far afield, then homes into a dense grass tussock for refuge.

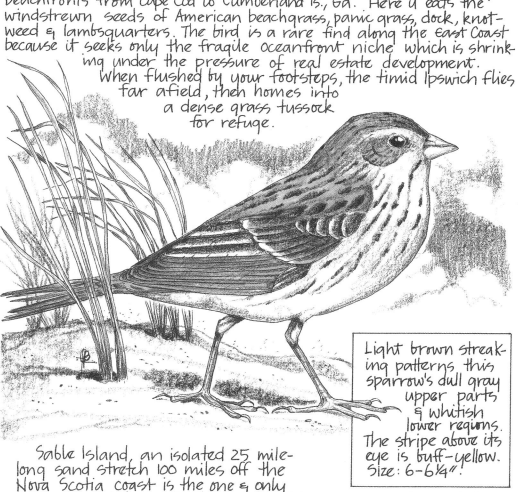

Light brown streaking patterns this sparrow's dull gray upper parts & whitish lower regions. The stripe above its eye is buff-yellow. Size: 6-6¼".

Sable Island, an isolated 25 mile-long sand stretch 100 miles off the Nova Scotia coast is the one & only nesting habitat sought by the Ipswich sparrow. It incubates 4-5 spotted, blue to gray eggs in a simple, ground-level cup fashioned from grass & weed stems. Parents feed hatchlings on droves of beetles, wasps, caterpillars, flies, spiders & snails plucked from nearby plants & shoreline flotsam—

BEACHES, OCEANS, & ESTUARIES

Chapter 2

Marshes & Wetlands

Anser caerulescens
Rare Winter

SNOW GOOSE

The snow goose is named for its almost pure white color & for the icy arctic climes where it secretly nests. This 25" waterfowl's pristine plumage is tainted only by black-tipped primary feathers & by a rusty-brown wash across the face. Fortunate is the islander who steals a glimpse of a snowy. Only freak weather such as blizzards or unseasonable cold (like the winter of '77) will drive the goose south to the Savannah River.

Along the East Coast, this goose will consume spartina grass, horsetail, wild rice & cattail seeds, greens & rootstocks. It feeds by grazing or by "swim-dredging". It floats on the surface, then plunks its head below to dislodge plants with its stout bill. During the food-grab, only its plump hind-end shows, pointing straight upwards___.

MARSHES & WETLANDS 41

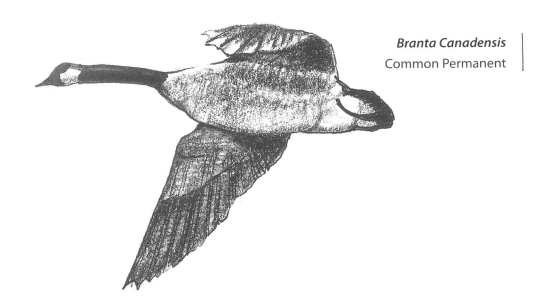

Branta Canadensis
Common Permanent

CANADA GOOSE

The sight of a pulsing line of Canada geese winging south for the winter is a rare 'birdwatcher's surprise here on the islands. These magnificent fliers normally inhabit the Chesapeake Bay area for the cold season, but flee unusually bitter weather, south to Florida. 25 to 43" in length, the Canada goose is recognized by its black head & neck which is collared by a white throat patch. The big fowl flock to marshy ponds, saltmarshes, mudflats & fields to rest & graze. Favorite geese edibles include spartina (cordgrass), widgeon grass & spike rush, as well as sea lettuce (seaweed). Their long necks enable them to reach deep underwater to snatch up plants by their rootstocks. Quantities of grit swallowed in the all-vegetarian meal serve as digestive roughage—.

The East Coast race of Canada Geese (1 of 10 subspecies) breeds in the Labrador Peninsula—Newfoundland area, above 50°N lattitude. 6 to 7 white eggs are nested in a mound of wet-land reeds, stems & leaves, lined with the famed, fluffy, goose down—.

t. Ballentine

MARSHES & WETLANDS 43

Aix sponsa
Common Permanent

WOOD DUCK

Local birdwatchers agree hands-down that the harlequin-hued woodie is our most beautiful duck. From its red-bridged bill to its cobalt-blue tail, the wood duck drake is all-color. Its body is adorned with blended black, white, green, blue & purple. An eloquent, emerald crest with stripes of white sweeps from the head to shoulders like a bridal train. Chestnut stains the breast & undertail. The belly is yellowish-white. On the dull-brown hen, an obvious fieldmark is the white eye-ring. In flight, both sexes show rectangular tails, iridescent backs & bobbing heads. Size: 17-20".

Hike into the woods... the boggier the better... to discover the wood duck. The bird is a hermit of shadowy swamps, streams & sink-hole ponds. Here it swims in small flocks, rests on floating timber & flies with agility between moss-draped trees. Extra-broad wings help the woodie beat through the branchy maze without collisions. To feed, the wood duck trods into dry forestland for acorns & other nuts, seeds & fruits. Spring-summer, insects, spiders & mollusks are eaten, especially by ducklings.

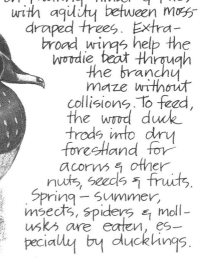

February through April, wood ducks nest in tree cavities, stumps or man-made "nest-boxes." Located 20-50 feet up to avoid floodwaters, the roost is cushioned with grass, twigs, feathers & down. The 8-14 eggs are cream-white. While molting nuptial plumage, flightless males guard hens & the clutch, & warn of danger (squirrels, 'coons, snakes), squealing, "weeet! weeet!" One enemy these ducks cannot escape: destruction of their backwater habitat by dredge & fill land development.

MARSHES & WETLANDS

Spatula discors
Common Winter

BLUE-WINGED TEAL

Warm-weather-loving waterfowl, blue-winged teal migrate to the southeast coast as early as October. They will linger in wetlands until April, when they wing northeast to breeding grounds from the Dakotas to Canada. These ducks are named for their light blue shoulder patches, displayed in flight. The marks glisten in the sun when these teal pass by at aerial speeds near 40 mph. By mid-winter, drakes wear a "nuptial" white facial crescent on their blue-black heads. Both sexes are tawny with dark breast spots and glossy green speculum. Females show a dull streaking on their backs. Size: up to 15½ in.

Blue-winged teals often congregate with green-winged teals in marsh creeks and ponds to feed. Blue-winged teals prey more on animals than do their cousins. They waddle on to mudflats to hunt snails, clams, and small crabs, as well as washed-up grass seed. When marshlands flood, blue-wings swim into the reedy thickets to consume green portions of algae, duckweed, pond weed, coontail, and wigeongrass.

BLUE-WINGED TEAL

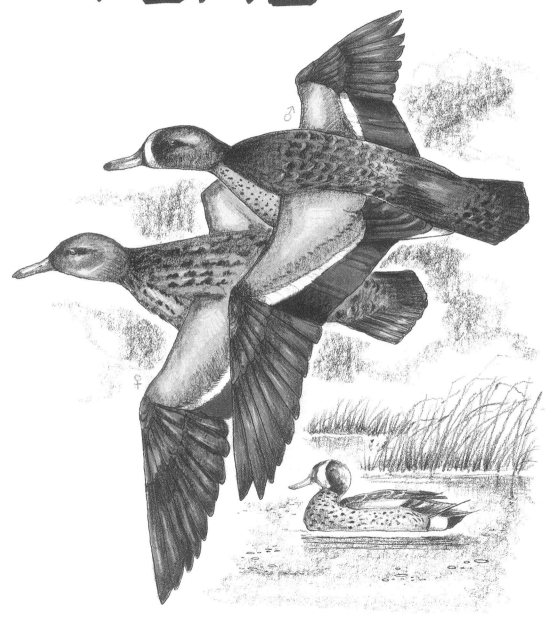

MARSHES & WETLANDS 47

Mareca strepera
Winter

GADWALL

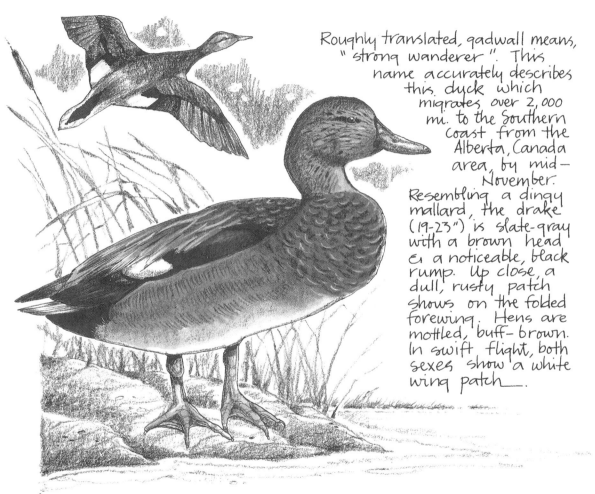

Roughly translated, gadwall means, "strong wanderer". This name accurately describes this duck which migrates over 2,000 mi. to the Southern coast from the Alberta, Canada area, by mid-November. Resembling a dingy mallard, the drake (19-23") is slate-gray with a brown head & a noticeable, black rump. Up close, a dull, rusty patch shows on the folded forewing. Hens are mottled, buff-brown. In swift flight, both sexes show a white wing patch.

Look for gadwalls on the shores of rivers, shallow marshes & ponds, abundant with underwater plants. Feeding in groups, the ducks dive to eat. Gadwalls gulp down seeds of soft-stem bulrush & the soft greens of widgeon grass, muskgrass, eelgrass, naiad, pondweed & red algae. At your approach, they will paddle out to open water. These ducks overwinter in our area until the end of February.

MARSHES & WETLANDS 49

Mareca americana
Winter

AMERICAN WIGEON

The American wigeon drake is easily recognizable by the "baldpate" white patch on its crown. This 18- to 20-in. duck is seen in the company of coots and redheads feeding in ponds, marshes, or bays. A weak diver, the wigeon grabs a bite by stealing fresh shoots of aquatic or brackish plants from the bills of fellow waterfowl. Farmers report that the bird also dines on waste sorghum and corn in fallow fields.

Warming winds of April find American wigeons migrating northwest to nest. Traveling in bunched flocks, the ducks show flashing white shoulder patches. Many nest in pothole marshes, from Alberta to Saskatchewan. Their homes, a weave of grass and stems lined with down, hold large clutches of white eggs. Some hatches, which occur in May, number up to twelve ducklings.

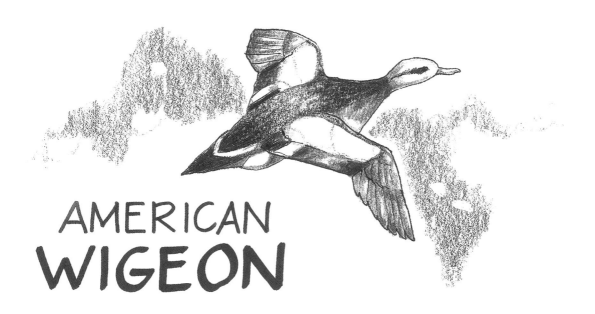

AMERICAN WIGEON

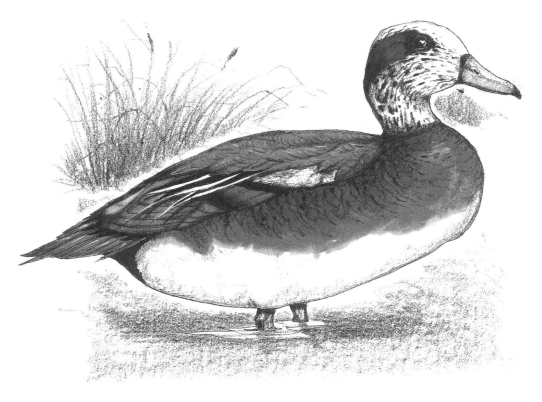

MARSHES & WETLANDS 51

Mareca penelope
Accidental

EURASIAN WIGEON

This duck breeds abundantly in the grassy marshes of Norway, Sweden, Lapland, and Scotland. But come wintertime, it is best known to migrate as far southwest as the South Carolina-Georgia-Florida coastal zone.

Watch for a solitary Eurasian wigeon in the company of flocking American wigeons. The 18- to 20-in. drake is known by its rusty-brown head with a cream-colored crown. Even the otherwise dull brown hen shows tinges of red on her face. This species dabbles to eat seeds and vegetation of grasses, rushes, and aquatic "weeds" which border bays, creeks, and ponds. In flight, it utters a high whistle, descending in pitch.

EURASIAN WIGEON

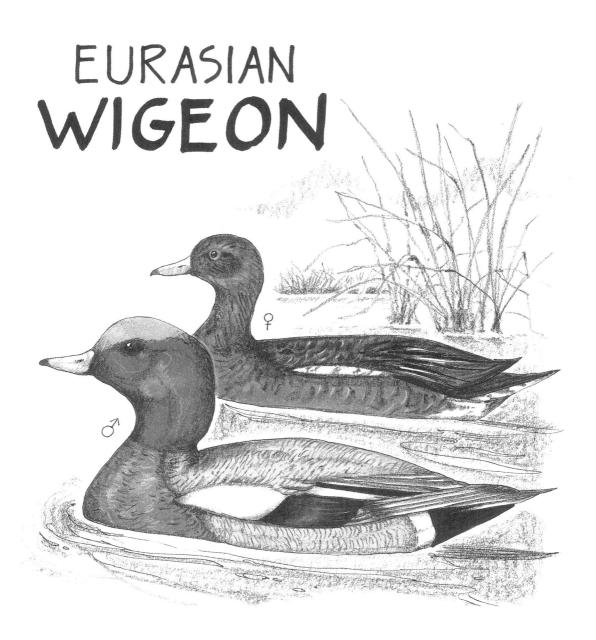

MARSHES & WETLANDS 53

Anas platyrhynchos
Common Winter

MALLARD

The mallard is the most familiar duck to migrate to the southern coast. Drakes are marked by a green head, white neck ring, chestnut-brown breast, and a black rump. "Susies" (hens) are streaked brown, for camouflage. Like all males, they wear blue-violet speculum. As hunters and birdwatchers well know, noisy "V" wedges of forty to sixty mallards are abundant here by mid-November. These "greenheads" flock to oak forests, fallow fields, rivers, ponds, and shallow salt creeks to feed. Typically, they dine by dabbling, a technique of tipping forward from the surface to scoop up bottom mud in their bills. By squirting muck out their beaks, the ducks strain plant seeds, stems and leaves, as well as insect larvae. When disturbed, mallards will spring straight upwards from the water.

First to fly northwest, by March mallards wing to the midwest states and to Manitoba and Ontario, Canada, to nest. Fewer numbers follow the Atlantic Flyway to northeastern breeding grounds.

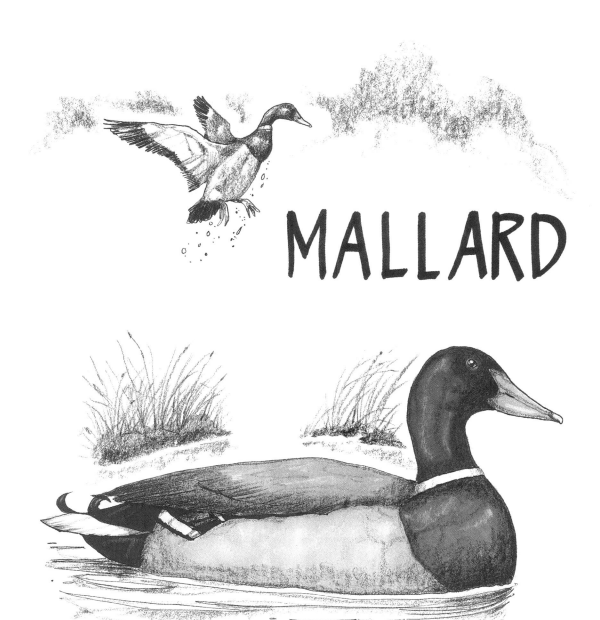

MALLARD

MARSHES & WETLANDS 55

ANATOMY OF A DABBLING DUCK

Certain ducks including the mallard, black duck, gadwall, pintail, shoveler & teals are called dabblers. When feeding, they tip their tails skyward & point their heads at the shallow underwater bottom. There they consume plant roots, shoots, leaves, seeds & insects, mollusks & crustaceans. Note the 6 ways dabbling duck bodies are specially suited to their lifestyle.

1. Short broad bill is used to pry loose animals & pull up plants. Water drains out sides of jaws.

2. Long neck enables the duck to reach deep down for food.

3. Feathers are waterproof. The duck uses its beak to smear an oily wax, secured from a gland near the tail, on its plumage.

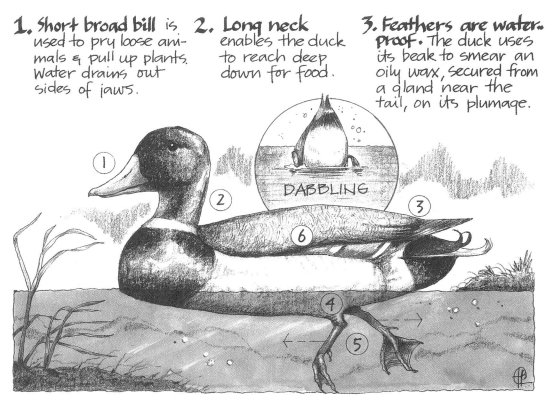

4. Legs are placed to the rear for forward propulsion.

5. Webbed feet are collapsable paddles. 3 toes are drawn open on the back-thrust & closed on the return.

6. Small wings do not weigh down the bird when it swims.

Anas rubripes
Winter

AMERICAN BLACK DUCK

Those of us who enjoy an off-trail hike or a sunset beach walk may well be re-warded with sightings of secretive American black ducks. These close cousins to mallards inhabit bottomland waterholes, sloughs, ponds, and coastal marshes. Here they feed on a variety of animals (snails, insect larvae, and fish) and plant seeds (pondweed, smartweed, pickerelweed, and spartina grass). 22 to 24 in. long, American black ducks are actually dark brown rather than black. In flight, they show distinct purplish-blue speculum, or white patches under the wings.

Hardy fowl, American black ducks migrate south sometime after Thanksgiving, following the freeze-over of northeastern marshes. By April, they wing north to breed from Cape Hatteras to eastern Canada. At this time, shoreline birdwatchers may detect their noisy mating game—a quacking mid-air game of tag!

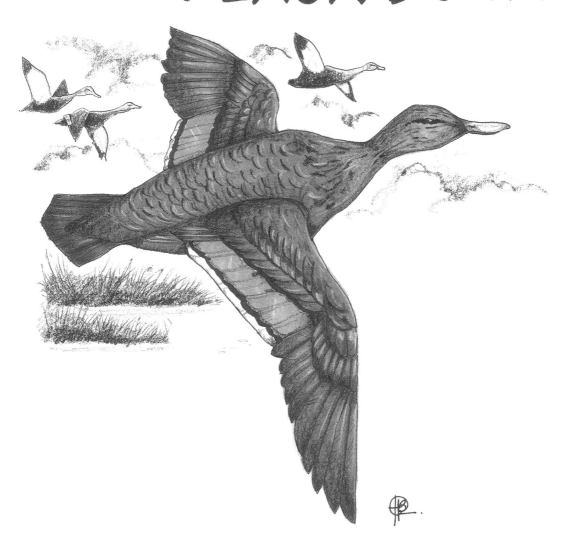

Anas acuta
Winter

NORTHERN PINTAIL

A pointed, 9-in. spike of central tail feathers is this duck's failsafe field mark. The slender northern pintail drake (21 to 25 in.) is gray above and whitish below, with a tapering white stripe running from its breast to its rich brown head. Hens are mottled brown and do not have the "sprig" tail. Both sexes show iridescent, bronze-green speculum when flying.

By mid-November, coastliners will spot pintail flocks streaming south in migration. Harried hunters have nicknamed this fowl "greyhound of the ducks" for its strafing, 80 mph speed and its steep descent to the ground. Its streamlined body and long, tapered wings are well-suited for such aerial acrobatics. Watch for pintails on the ocean, at rest, or in salt marsh creeks, where they feed from the surface. Vegetation—glasswort, widgeon grass, muskgrass, bulrush, and tall redtop— is commonly consumed. Fiddler crabs and snails may be gobbled from nearby mudbanks. By Saint Patrick's Day, pintails will begin migrations north to breed.

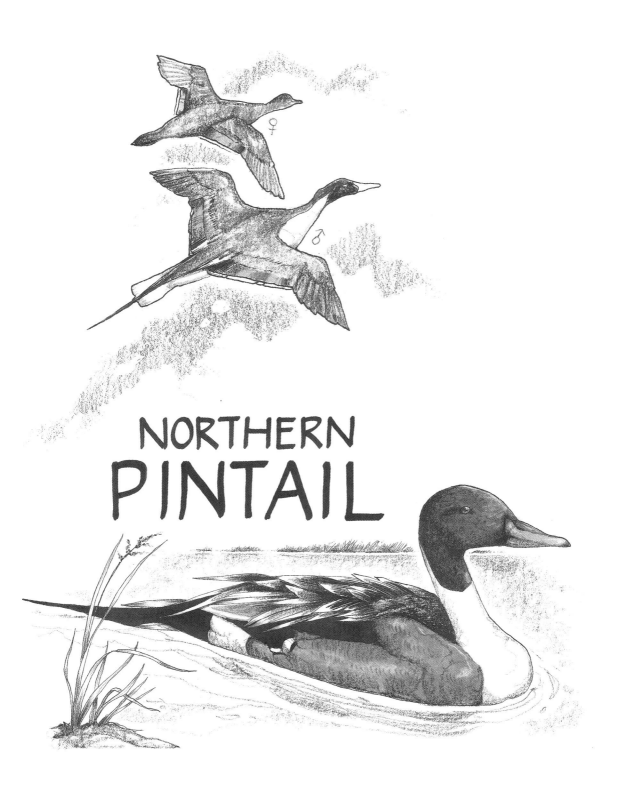

NORTHERN PINTAIL

MARSHES & WETLANDS

Anas crecca
Common Winter

GREEN-WINGED TEAL

In the winter, green-winged teal are more common in South Carolina than in any other southeastern coastal state. Seventy percent of all green-winged teal migrate to rivers, marshes and flooded rice fields, so abundant in the Lowcountry. Here they may be described as the "mud teal," for their method of pecking up seeds, insects, and snails from the muck banks. Strong afoot, they will hike great distances through reeds and grasses to feed or escape predators. Floating males are cinnamon-headed and show a green eye patch, a spotted pink breast, and a vertical white patch on their sides. Hens wear a brown camouflage. Like the drakes, they are best identified in flight by their "teal," an iridescent green wing patch. These ducks will migrate north to northeastern Canada, or to Ontario, by April to breed.

As small as pigeons, (13 to 15½ in.), green-winged teal fly in tight, twisting flocks of fifty to one hundred ducks.

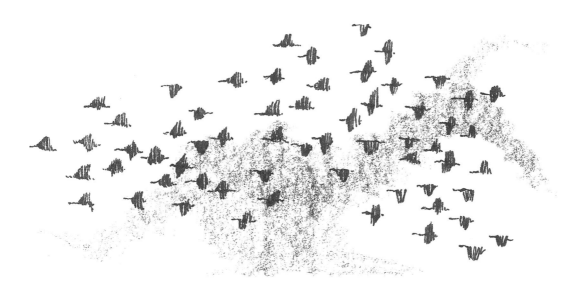

GREEN-WINGED TEAL

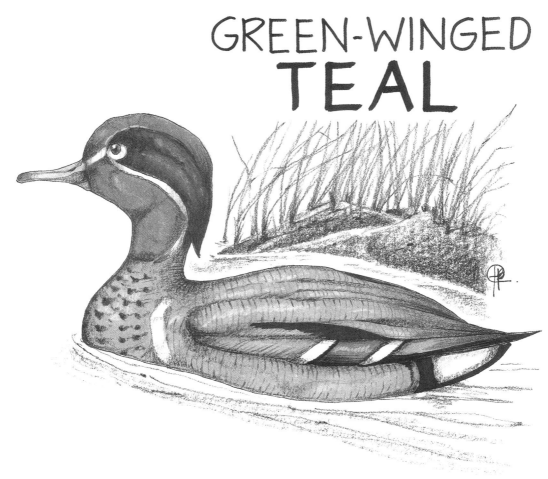

MARSHES & WETLANDS

Podilymbus podiceps
Common Permanent

PIED-BILLED GREBE

The onset of Autumn finds more & more pied-billed grebes swimming the island's lakes, ponds, marsh pools & inshore waters. The 13" birds are easily identified by habitat & color. Their short, stout bills look like the beak of a hen & show a "pied" ring in breeding season. Plumage overall is brown, though the underneck is black & the rump is splashed with white.

Nicknamed "helldivers", these grebes are skilled at plunging deep & swimming underwater. They propel themselves with their "lobate" feet, on which each toe has a flattened, fleshy membrane that functions as a paddle. Food includes aquatic beetles, crawfish, minnows, leeches, snails & seeds. On the surface, these grebes float erectly, or can submerge themselves, periscoping only their heads & necks if predators are near.

Born of the water, 6-9 black & white striped young hatch each summer in a floating nest. The raft-like roost is a weave of dead plants, cemented with mud & anchored to nearby reeds. Eggs are whitish-green.

MARSHES & WETLANDS 65

Gallinula galeata
Permanent

COMMON GALLINULE

Like its cousin, the purple gallinule, the 13" common (Florida) gallinule pokes around the margins of freshwater ponds, marshes & sloughs where overhanging greenery forms hideaways. But its plumage is distinct: the slate-gray body is tinted with earth-brown on the back; white streaks the flanks & colors the undertail coverts; a red facial shield blends into a scarlet, yellow-tipped bill. This species ranges as far north as Canada to breed & over-winters from the Chesapeake Bay to the Gulf states.

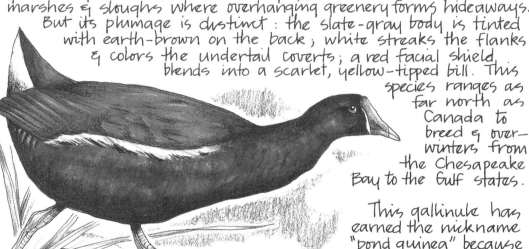

This gallinule has earned the nickname "pond quinea" because it struts like a chicken through floating marsh plants in search of aquatic seeds, stems, insects or snails to eat. Trapsing along with long, green legs & unwebbed toes, it lays down well-worn trails in the reeds. When it swims, the common gallinule bobs its head & clucks a hen-like "kuk" sound.

Nestbuilding gallinules pile dry vegetation in a buoyant raft which will rise & fall with changing pond levels. They lay 6-12 sparsely spotted, buff-white eggs. Parents must keep a constant vigil for enemies like egg-eating snakes or alligators, snapping turtles & frogs which attack the red-faced, black hatchlings.

MARSHES & WETLANDS

Porphyrio martinicus
Summer

PURPLE GALLINULE

Radiant plumage distinguishes this 13" gallinule from all other marshbirds. Its head, neck & underparts are deep purplish-blue. Upper parts are glossy green. A light blue facial shield is located just above the yellow-tipped red bill.

The purple gallinule inhabits freshwater ponds, marshes & swamps from Florida to central South Carolina. A short-hop flier & a sometimes swimmer, the bird is best at strutting across lily pads to feed. Its long, chicken-like toes que balance on the floating, green rafts. Here the "blue pete" eats windblown grass seeds or insects, spiders & snails which are pecked off the undersides of leaves that it rolls over with its foot. Voice: a clucking, "kek, kek, kek!"

April through May, purple gallinules build their bowl nests of matted reeds, rushes & grasses just above the water line. A tent of tall plants is pulled down to cover the clutch of six to ten spotted, cream-colored eggs. The downy-black chicks spring from stem to stalk soon after hatching. These gallinules overwinter from peninsular Florida to Argentina.

MARSHES & WETLANDS 69

Fulica americana
Common Winter

AMERICAN COOT

Often mistaken for a duck, the American coot is one of our most abundant winter waterbirds. The 13-16" coot is easily identified by its slate gray body & its black head & neck. Its contrasting white bill & undertail show at a great distance. This "mud hen" flocks to our freshwater lagoons, ponds, lakes & marsh sloughs, to swim & feed. It eats duck-weed & seeds from the surface, but tips its head underwater to consume aquatic roots, insects or snails. Fleshy "lobes" (not webs) on its feet provide propulsion for diving. When alarmed, the coot madly skitters or runs along the surface while laboriously lifting its bulky body aloft. This awkward antic is the inspiration for the idiom, "crazy as a coot!"

By April, coots migrate to the Great Lakes area, or to the states west of the Mississippi River, to nest. They weave floating mats of dead vegetation which are anchored to nearby reeds & grasses. 8 to 12 downy, black chicks hatch one by one, one per day. Each cootlet is immediately led to water by a parent & soon swims like an expert.

MARSHES & WETLANDS 71

Scolopax minor
Permanent

AMERICAN WOODCOCK

The chubby, no-necked American woodcock is a case-study in avian adaptability. Its "dead leaves" upper plumage, black-barred crown & tawny underbelly render perfect camouflage in brushy habitats. Hikers traipsing through swamp woods, weedy pond edges or pastures might step on the nearly invisible bird before it reveals itself. Built for a life of probing, this "mudsucker" employs its long, flexible bill to pluck up worms, slugs, insects & crustaceans wriggling underfoot. Big eyes located far back on the face allow the wary woodcock to scan its flanks for enemies while it bends to feed.

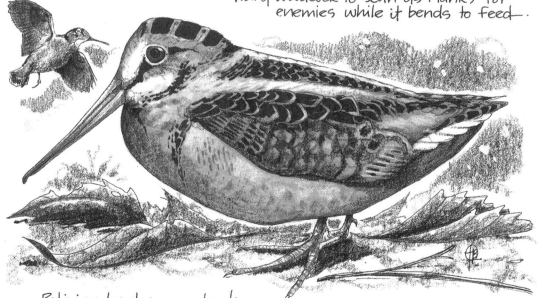

Retiring by day, woodcock grow boldly active after sundown. Twilight's stretching shadows find them foraging & in the spring, courting. Rasping his "beesp!" flight song, the amorous male spirals skyward, then flutters to the ground, "cheeping" softly. This repeated maneuver & a strong dose of strutting machismo wins the hen. Protectively colored, the mates nest openly on a leafy bed. Their 4 buff-brown eggs are spotted at one end. When predators threaten, parents fly to safety with hatchlings wedged firmly between their legs.

MARSHES & WETLANDS

Anhinga anhinga
Permanent

ANHINGA

Its neck is slender and crooked like the body of an uncoiling serpent. Its bill is rapier-shaped, and its elongated tail measures half its body length. The streamlined anhinga (34 in.) is a black-bodied denizen of freshwater swamps, ponds, and rivers. The male displays silver streaking on its wings when they spread apart to sun dry. Tan head and neck plumage field marks the female.

Secretive by nature, the anhinga prowls for small fish, frogs, and snakes in secluded backwaters. The bird typically swims entirely submerged with only its neck and head periscoping up. With a darting lunge, it impales prey on the point of its beak. No other bird flies like the anhinga. Flapping and gliding in soaring circles, it extends its face far forward and fans its tail.

Anhingas nest in colonies, often with other species of wading birds. Entwined sticks and branches lined with foliage, green twigs, Spanish moss, and moss is the roost for two to five bluish eggs. They are crusted over with a chalky covering which, looking like guano, camouflages the clutch.

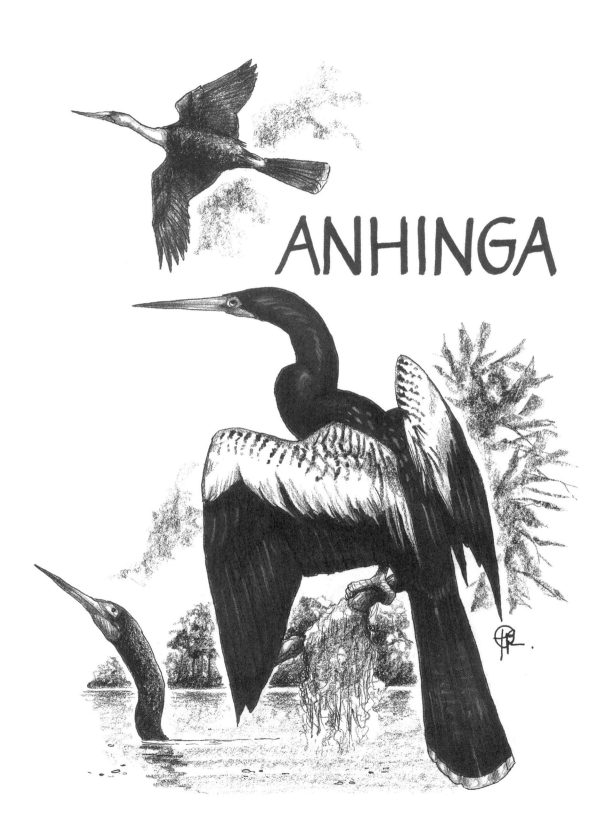

MARSHES & WETLANDS

Megaceryle alcyon
Common Permanent

BELTED KINGFISHER

With its banded breast, scraggly, crested crown, and precision diving ability, the belted kingfisher has justly earned its name. This ratchety-voiced bird perches hunched over an outcropping limb near open waters, lagoons, or marsh creeks— wherever fish are found. It hunts by hovering 15 to 50 ft. above the surface, then plunging in headfirst to snare small fish. (Imagine the strong eyesight this bird needs to locate its finny quarry in the murky depths, from such heights!). Pinched in the 'fisher's strong beak, squirming prey is carried back to the perch, beaten to death, and devoured . . . or carried to the nestlings. Other food includes crayfish, lizards, frogs, insects, mussels, and wild berries. May to June, belted kingfishers nest in excavated burrows . . . to a length of 6 ft. in mudbanks, near water. Hollow trees, stumps, and vacant bird nests are also used to shelter six to eight shiny white eggs.

Identify the 11- to 14-in. belted kingfisher by its large head with a shagged crest and a big black bill. Back and tail: bluish gray; white underparts are marked with a visible bluish chest stripe, and rusty breast/side markings on females. Note that the kingfisher has weak feet and seldom walks on solid ground.

BELTED KINGFISHER

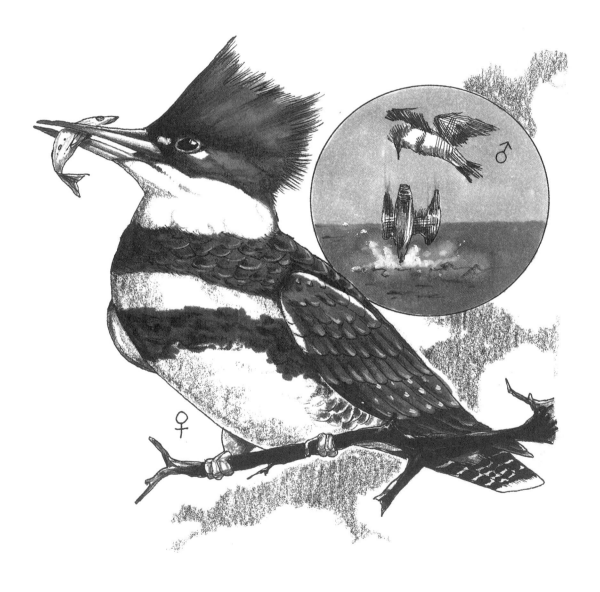

MARSHES & WETLANDS

Ardea herodias
Common Permanent

GREAT BLUE HERON

The largest of the American herons, the 50-in. great blue heron stands head and shoulders above fellow wading birds. It is named for its cobalt-gray body coloring. Black plumes cresting its white forehead are noticeable through field glasses. Stilt-like legs ending in wide-spreading toes enable the great blue heron to steal out into the murkiest swamps and marsh creeks, or to stalk the slimiest mudflats. Here it ambushes fish, snakes, crustaceans, and even young alligators with a sudden thrust of its long yellow bill. When it rests or flies, this heron draws its neck into a flattened "S."

In the early spring, great blue herons wing en masse to wetland rookeries. They return year after year to the same cypress-tupelo swamps where they nest by the hundreds in the loftiest limbs. Three to six eggs are placed and incubated in a deep bowl of sticks lined with grass and leaves. Hatchlings sup on semi-digested food which a parent regurgitates into their beaks.

GREAT BLUE HERON

MARSHES & WETLANDS 79

Ardea alba
Common Permanent

GREAT EGRET

White knight of the wading birds, the great or American egret is known by its snow-colored plumage, bright yellow beak & black legs & feet. During spring, about 50 straight "aigrette" plumes trail daintily from the bird's back to a foot beyond the tail. Though large-sized (38-42" length; 4½ ft. wingspan), the "long white" is easy to approach & observe.

Watch this egret stalking marshes, creeks, mud-flats, ponds & lagoons. Craning a crooked neck forward, it advances on measured strides, often knee-deep in water. A lightning-quick thrust of its saber-bill pinches small fish, crustaceans, snails, frogs, lizards & even grass-hoppers & mice. An alarmed egret coughs a harsh, croaking call.

Are birds romantic? If you study pairing egrets, you'll think so. In March, strutting males flare plumes to court mates. They will wing to cypress-tupelo gum swamps to nest in a rookery... a crowded neighborhood of breeding herons, egrets, ibises & anhingas. Parents heap together clumsy platform-nests from twigs, Spanish moss & leaves. Ample guano mortars the mass into semi-solidity. Hatching from aqua-blue eggs, 3-5 young are first fed once-digested fish regurgitated from adults' bills. The babies' enemies are sky-raiding crows & vultures, or alligators trolling black waters 30 ft. below the nursery.

MARSHES & WETLANDS **81**

Egretta tricolor
Common Permanent

TRICOLORED HERON

Ornithologist John James Audubon lyrically portrayed the tricolored heron as a "Lady of the Waters." No doubt the renowned naturalist appreciated the bird's demure, tricolored plumage. Above, this heron is misted, purplish blue. Light chestnut aigrettes trail from the back. The white underparts are obvious even at a distance. Size: up to 26 in.

The tricolored heron ranges from the Chesapeake Bay to the Texas Gulf coast. Favored hunting haunts are edges of wetlands, marsh creeks, shores, and meadows. Unlike some wading bird cousins, this heron does not stand on ceremony to feed. It strides purposefully through shoals and clumped grass, beak-striking killifish, frogs, tadpoles, insects, snakes, worms, and lizards.

Colonial tricolored herons nest en masse with egrets, fellow herons, and anhingas in wooded swamps. Their fragile, dried-stick nests are propped in willow or mangrove limbs, 2 up to 20 ft. high. The two to five eggs are bluish. Youngsters wear no plumes for the first year and are rusty brown above, white below.

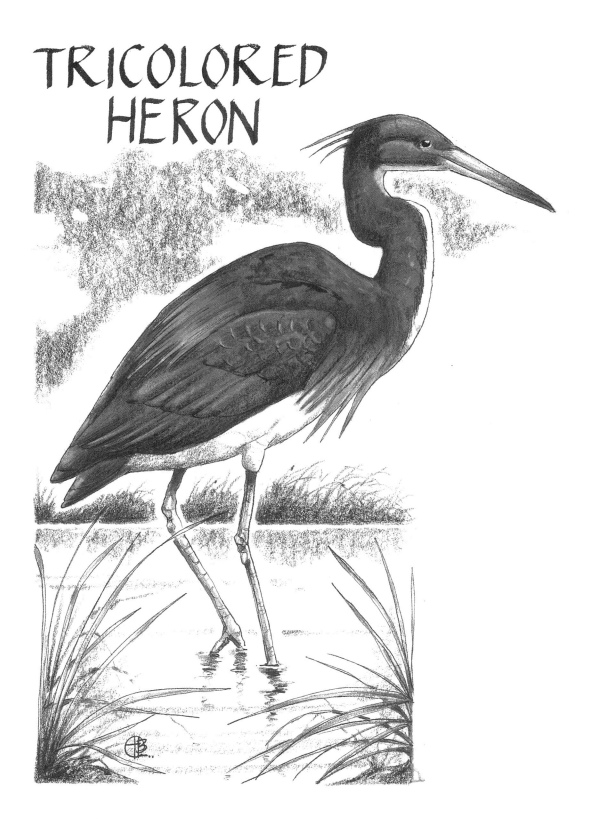

Eudocimus albus
Permanent

WHITE IBIS

The white ibis is famed for its long, downcurved beak. By sweeping it back and forth through water, it captures crawfish, crabs, shrimp, small fish, frogs, and insects inhabiting marshes, flooded patties, and mangrove swamps. From March to late summer, the 22- to 27-in. ibis is seen flying in long trains from feeding grounds to nest sites miles inland. This wading bird's body is pure white, and its bill, face, and legs are scarlet. Black wingtips show when it circles overhead in a slapping, then gliding pattern.

The homing instinct draws white ibises to the same rookery swamps year after year. In these rookeries ibises nest in close quarters. As a result, brooding is accompanied by lots of squabbling among birds, including theft of nesting material from nearby nests. Their three to six light green eggs, spotted with brown, are nestled in a crude cushion of sticks placed to 15 ft. above ground.

WHITE IBIS

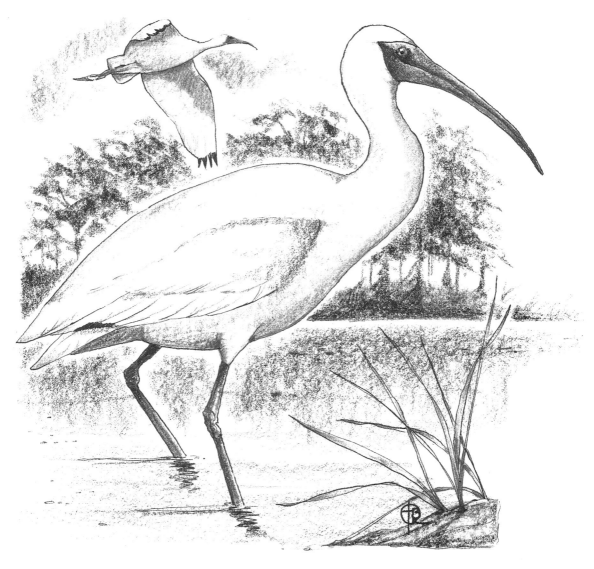

THE ROOKERY

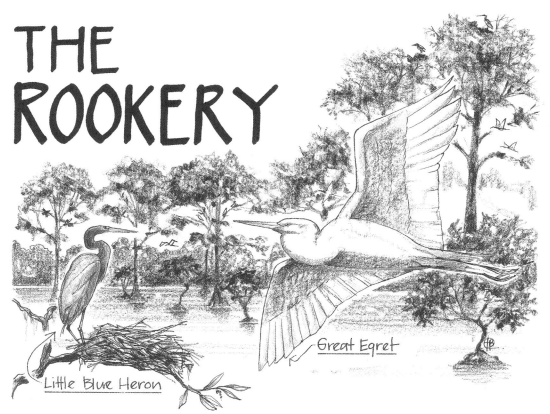

Little Blue Heron

Great Egret

If you want to capture close-up views or a photographer's trophy of wading birds, then visit a rookery. It is a breeding colony for herons, egrets & ibises (as well as anhingas, warblers & blackbirds). A typical rookery is located in a swamp... a stand of bald cypress or tupelo trees flooded by river water, run-off or springs. Probably less than a dozen large rookeries remain on the S.E. coast because the wetland habitats have been destroyed by land development, drainage & logging.

Seeing the residents at roost reminds you of a too-crowded tenament of stick & guano flats. There are nests in every limb & at all levels. Great blue herons perch in highest penthouse pinnacles, great egrets own the middle stories & smaller avians inhabit twiggy bottom floors. The birds dwell so closely together that they nearly rub shoulders. This bunching allows for common defense against aerial predators like fish crows & vultures, which eat eggs. The black water moat foils invasions of raccoons, squirrels & upland snakes from below. Various species nest at different times. For instance, in South Carolina, insect-eating cattle egrets breed early to feed on spring's first bounty of bugs. Their abandoned homes are inherited by white ibises which hunt crustaceans developing in marshes where water temperatures heat up slowly.

MARSHES & WETLANDS

WADING BIRD NICHES

At least 17 species of wading birds inhabit the shorelines, estuaries & wetlands along the southeast coast. They come in all shapes & sizes. Most feed on fish, crustaceans, mollusks, frogs, snakes, worms & insects. But no two birds feed alike. Each avian develops a specialized way to hunt called its niche. Below are shown our most commonly seen waders in their niches.

① THE **SNOWY EGRET** (20-27") HUNTS ALONG GRASSY SHORELINES.

② THE **GREAT EGRET** (38") WADES "ANKLE-DEEP" IN SHALLOW WATER.

③ THE **GREEN HERON** (16-22") HUNTS WELL CAMOUFLAGED BY TALL VEGETATION.

④ THE **WHITE IBIS** (22-27") SWEEPS ITS DECURVED BILL IN THE WATER OR PROBS MUD & SAND.

⑤ THE **GREAT BLUE HERON** (42-52") STANDS "KNEE-DEEP" IN WATER, PLUNGES ITS BEAK, HEAD & NECK ENTIRELY UNDERWATER FOR LARGER PREY.

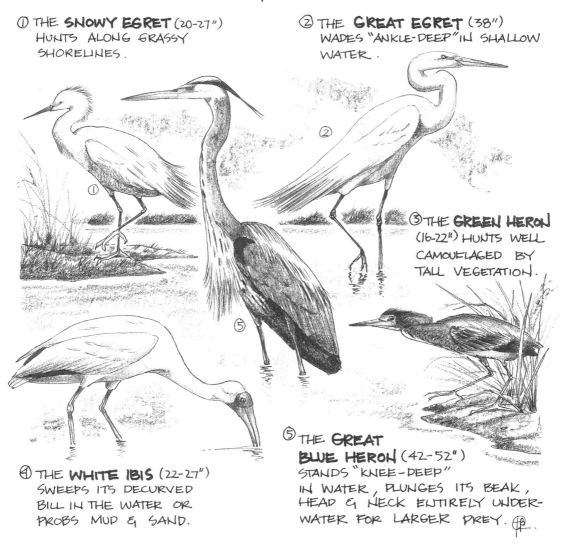

MARSHES & WETLANDS

Chapter 3

Fields & Open Areas

Zenaida macroura
Common Permanent

MOURNING DOVE

Well-known for its muted, cooing song, "ooah-ooo-ooo," the mourning dove inhabits grassy edges of woodlands, roadsides, powerlines, orchards & fields, from Maine to Florida. Here the bird feeds on seeds (corn, cowpeas, grasses, ragweed & other weeds, trees), fruits & an occasional grasshopper. Many fieldguides portray this dove at roost on telephone wires or fencetops; its feet are designed for both long walks & perching. I have been most intrigued by the way the mourning dove drinks water in puddles. It dunks its bill in to the nostrils until completing the draught. A bird with a belly-full of liquid flies low to the ground.

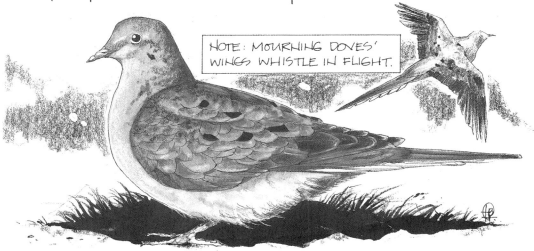

NOTE: MOURNING DOVES' WINGS WHISTLE IN FLIGHT.

Nest architecture is not a mourning dove's forté. Stashed in briars or on pine limbs, the homes are flimsy piles of twigs & pinestraw that barely keep the two white eggs from dropping through the floor! Two or three broods are hatched annually. Youngsters feed by thrusting their beaks into their parents' mouths. Adults regurgitate predigested seeds mixed with a whitish liquid called "pigeon's milk" which is produced in their crop.

Fieldmarks: Grayish-brown above; flesh-tan below. Wing shoulders show black spots. The pointed tail is white-spotted on the sides. Size: 12" beak to tail-tip.

FIELDS & OPEN AREAS

Charadrius vociferus
Common Permanent

KILLDEER

Olive brown above, white below, the 9-11" killdeer is recognized by its two black breast bands. In flight it displays a warm-golden wash on its rump. This noisemaker is named for its shrill call, "kill-dee", which it repeats when alarmed.

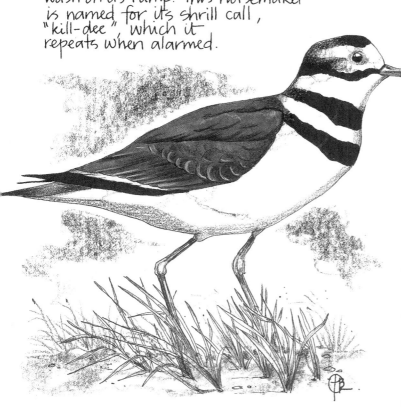

Technically classified a shorebird, the killdeer is more native to lake & lagoon banks or meadows & fields. Here it hunts hordes of insects (mosquitos, grasshoppers, crickets, weevils, beetles, grubs), ticks & crayfish. Because this bird exterminates pests to public health, livestock, agriculture & fisheries, it is a member of the U.S. Department of Agriculture Honor Roll.

The sociable killdeer breeds with others of its species in grass or cotton/corn stubble near water. Four blotched, dull-buff eggs are roosted in a shallow cavity in the ground. If an enemy intrudes, the female decoys it away by staggering, gasping & dragging its wing to feign injury———.

FIELDS & OPEN AREAS

Bulbulcus ibis
Common Summer

CATTLE EGRET

To survive in the world of nature, an animal must carve out its own "niche"— a special function or habit no other creature shares. The cattle egret has staked its claim to near-coast pastures, furrowed fields, highway shoulders & wetlands. Typically, it struts stride for stride with livestock & horses, gulping grasshoppers, crickets & flies which are stirred up by grazing. Also, it perches on the mammals' big backs & preens ticks out of hair & fur.

This "cowbird", as it is locally called, is 20" long & looks like a smaller, stouter version of the snowy egret. Both are pure white. But the cattle egret's bill is yellow, &, in the spring, buff-orange coloring washes its crown, back & chest.

The cattle egret immigrated 3,000 miles to North America in 1952 from Africa, by way of Guyana. Presently it ranges as far north as Massachusetts to nest. Three or four young are raised in shoddy stick platforms wedged into shrubs or saplings, in swamp rookeries. By August this egret flees to peninsular Florida & the Gulf states to overwinter.

FIELDS & OPEN AREAS 97

Cathartes aura
Common Permanent

TURKEY VULTURE

Too many Westerns have cast high-soaring "buzzards" as villains. Truth is, turkey vultures feed only on carrion—dead and decomposing animals. Their unenviable menu makes these "nature's garbage collectors" valuable members of the environment: they keep the landscape free from decay.

Turkey vultures scavenge from the air. As the morning sun ascends, they perch in trees and stretch out their long (6-ft. span) wings. Soon they will soar effortlessly on rising thermals (warm air currents), tipping, but seldom flapping, flight feathers arced to capture breeze. Even from such dizzying heights, vultures locate food by using excellent eyesight and perhaps a powerful sense of smell.

In flight, the turkey vulture appears coal black with gray primary feathers. The tail is long and rectangular. This bird is commonly encountered gorging along roadsides. Here the adult shows its naked, red "turkey" head. Warning: do not approach a feeding "buzzard." The overstuffed and self-protecting avian is known to vomit on intruders!

Turkey vultures lay two to three brown-spattered, white eggs on the ground or in saw palmettos, logs, and cliffs. Gray-headed young ride their first thermals at seven weeks of age.

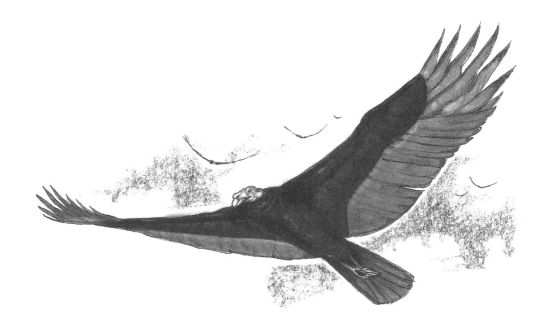

TURKEY VULTURE

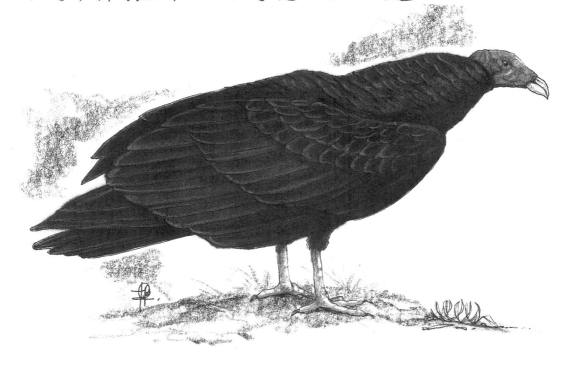

FIELDS & OPEN AREAS

Falco sparverius
Common

AMERICAN KESTREL

The most obvious place to locate the American kestrel is at perch on a power line, adjacent to a rural roadway. Here the small (9 up to 12 in.) falcon sits, poised to hunt grasshoppers, crickets or rodents in grassy shoulders and nearby meadows. Occasionally, this kestrel attacks young birds which explains its nickname, "sparrow hawk." The bird is adept at "wind-hovering," its technique of remaining motionless in the air by rapidly flapping its pointed wings, then diving talon-first on prey below. Dead tree cavities, abandoned woodpecker borings, and rotted crevices in old barns are favorite kestrel nest sites. Here are brooded four to five eggs that are speckled and splashed with a palette of red and brown hues.

The American kestrel is easily identified by its rufous-colored back and tail, rusty streaks on its light underparts, and black streaks on its face and neck.

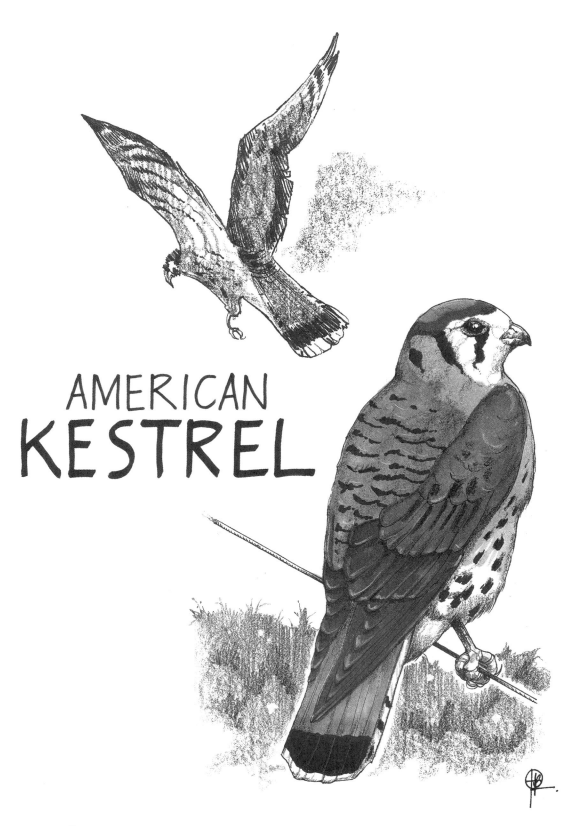

FIELDS & OPEN AREAS 101

Tyrannus tyrannus
Summer

EASTERN KINGBIRD

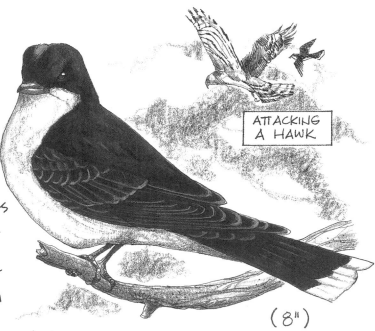

ATTACKING A HAWK

(8")

Speed, courage & outright aggression have earned this flycatcher the name, Kingbird... for truly, it rules its territorial skies. It will chase away any hawk, vulture or crow which approaches by pecking at its back. Like a fighter plane strafing some lumbering bomber, the more agile kingbird always wins its avian dogfight.

If such behavior seems belligerent, it is necessary because the Kingbird nests so openly on exposed stumps or limbs near water. It builds a bulky bowl of twigs, grass, rootlets & hair for 3-5 cream-white eggs, blotched by browns. Lacking protective cover, the kingbird must attack all possible predators of its brood.

Watch the Kingbird perch on wires or shrubtops bordering open grasslands, roadsides or farms. From this vantage point they dive down to hunt insects. Grasshoppers, flies, ants, beetles & bees are favorite foods. When it flies, its wings quiver & only the tips appear to move. Fieldmarks: black face, back & tail; white underparts; a concealed red crown patch; a distinct white band across the tip of the tail.

FIELDS & OPEN AREAS

Tachycineta bicolor
Common Winter

TREE SWALLOW

The invasion of clouds of tree swallows to the Carolina sea isles is a naturalist's tip that hard frosts are coming soon. By November, tree swallows are seen in the skies over salt marshes, beaches, open water & hedgerows; or queued shoulder-to-shoulder along power lines. They fly in dizzy circles, first gliding, then ascending with 3-4 quick flutters of their saber-shaped wings. Identify either sex by the stubby, short body (5-6") which is pure-white below, metallic greenish-black above. The tail is slightly forked.

*TREE SWALLOWS SWARMING OVER WAXMYRTLE SHRUBS IS A COMMON FALL PHENOMENON.

During cool seasons, tree swallows feast on the fruits of waxmyrtle (bayberry)*, red cedar, Virginia creeper & dogwood. This appetite for plant matter is atypical of other swallows. 80% of the tree swallow's diet year-round consists of mosquitos, flies, midges ("no-see-ums"), wasps & bees, moths, grasshoppers, bugs & spiders.

With the first sign of a spring thaw, tree swallows migrate to the Chesapeake Bay & north to breed. Paired mates inhabit nest boxes, stumps, tree cavities & woodpecker holes. Their 4-6 clean white eggs are nestled in a comforter of dried grass, weed stems & feathers. Brown-backed young resemble bank swallows (rare, transitory) & rough-winged swallows (seen only in summer).

FIELDS & OPEN AREAS 105

Progne subis
Common Summer

PURPLE MARTIN

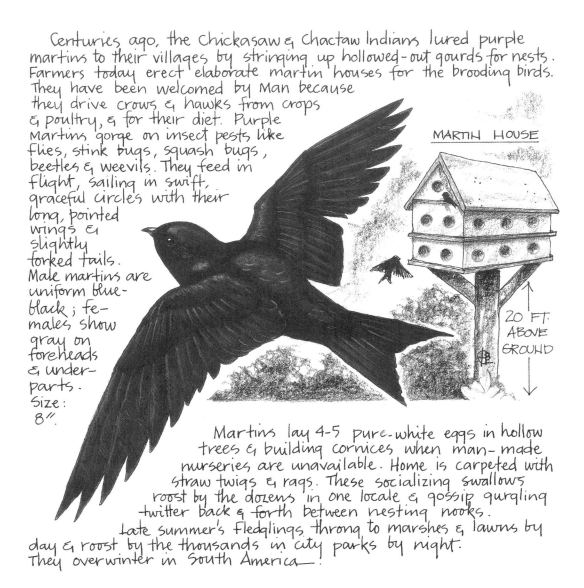

Centuries ago, the Chickasaw & Chactaw Indians lured purple martins to their villages by stringing up hollowed-out gourds for nests. Farmers today erect elaborate martin houses for the brooding birds. They have been welcomed by Man because they drive crows & hawks from crops & poultry, & for their diet. Purple Martins gorge on insect pests like flies, stink bugs, squash bugs, beetles & weevils. They feed in flight, sailing in swift, graceful circles with their long, pointed wings & slightly forked tails. Male martins are uniform blue-black; females show gray on foreheads & underparts. Size: 8".

MARTIN HOUSE
20 FT. ABOVE GROUND

Martins lay 4-5 pure-white eggs in hollow trees & building cornices when man-made nurseries are unavailable. Home is carpeted with straw twigs & rags. These socializing swallows roost by the dozens in one locale & gossip gurgling twitter back & forth between nesting nooks.
Late summer's fledglings throng to marshes & lawns by day & roost by the thousands in city parks by night. They overwinter in South America—!

FIELDS & OPEN AREAS 107

Sialia sialis
Common Permanent

EASTERN BLUEBIRD

Henry Thoreau called this colorful thrush the bird that "carries the sky on its back." The male Eastern bluebird (7") is easily known by its sea-blue head, back, wings & tail, worn in contrast with its chestnut red throat & breast. Although duller above, the female still sports a bright azure tail.

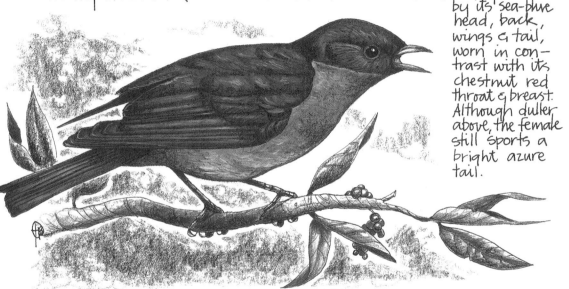

This bird is a welcome herald of spring here. Beginning February, it calls, "chur-wi," from fence posts, power lines, roadsides, cutover fields & orchards. Later, its cool weather diet of fruits, berries & seeds gives way to an endless hunt for animal protein. The bluebird hops from limb to limb, ambushing caterpillars & spiders. Worms, beetles & centipedes are devoured on the ground. By August it feeds on hosts of grasshoppers... over 50% of its daily edibles in summer.

In nature, bluebirds nest in hollows... in trees, stumps or abandoned woodpecker borings. They may be successfully attracted to manmade nest boxes. Affixed atop an 8-12 ft. pole, the box should be designed with a 1½" entry hole to keep out starlings. Fertile bluebird couples may raise 3 broods of 4 to 6 young each season___.

FIELDS & OPEN AREAS

Anthus rubescens
Winter

AMERICAN PIPIT

Autumn's long shadows highlight the arrival of the American pipit to our fallow fields, bogs, and shores. Here the slender, sparrow-sized migrant plucks insects and seeds from farm stubble and wild grass, grubs out worms from plowed earth, or hunts down tidepool invertebrates. This bird is specialized for such undercover eating. Its hind toes are as long as the foretoes, enabling it to stride, not hop, along the ground after prey. The narrow bill serves to glean tiny morsels from even the hardest to reach hiding places.

Field marks for this 6- to 7-in. avian are inconspicuous. Gray brown above, the bird is streaked, pink buff below. White outer feathers fringe the notched tail. But a boring personality the pipit hasn't. Jogging across the turf to forage, its head nods and its tail wags like a weathervane in a sea breeze. When frightened, it swoops upwards in circles, sometimes soaring 200 ft. high. Its mid-air call, "pip-it!" gives the bird its name. The American pipit is nicknamed "wagtail" because it habitually flicks its long tail feathers.

Cold-craving American pipits breed from Newfoundland and west through the Hudson Bay region, into the Arctic tundra. They pack together a ground-nest of dried grass and moss. Their four to six chocolate-brown eggs are camouflaged with dark spots and streaks.

AMERICAN PIPIT

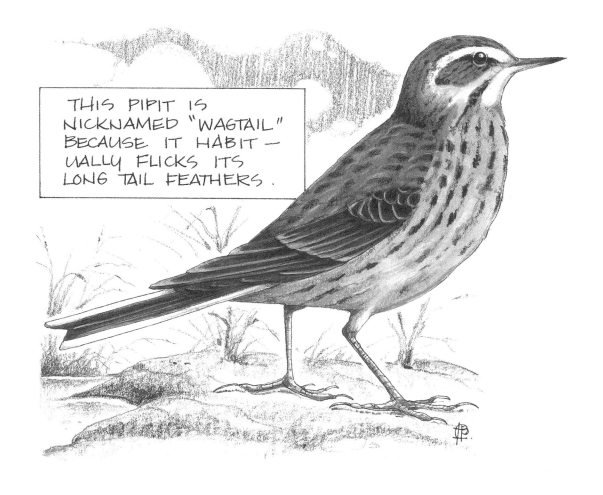

THIS PIPIT IS NICKNAMED "WAGTAIL" BECAUSE IT HABITUALLY FLICKS ITS LONG TAIL FEATHERS.

Passerculus sandwichensis
Common Winter

SAVANNAH SPARROW

This sparrow is named for the treeless, grass marshes, dunes & fields called savannas or savannahs in the south, where it abides. Arriving early in autumn migrations, it scampers like a rodent between yellowing blades, spurting nervously ahead, then halting to feed. It consumes sizeable quantities of weed seed (panicgrass, goosegrass, pigweed) & insects (beetles, boll weevils, caterpillars, grasshoppers) which are bothersome to cool weather truck farmers here. Hard to spot until flushed, the bird can be first located by its "tsip" call. Fieldmarks: 5¼-6" in length; dark umber streaking marks the tawny back & whitish underparts. A yellow stripe above the eye is usually evident; the short tail is slightly forked.

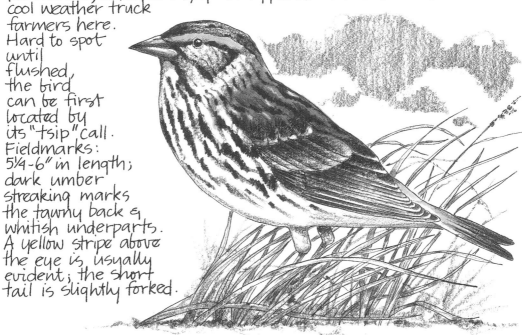

Savannah sparrows nest from Connecticut to regions as far north as Hudson Bay. Parents pack green stems & stalks into a cushion where they brood 4-5 bluish-white, spotted eggs. Their striped plumage enables them to blend with the long prairie grass shadows so that they may hide from predator foxes, skunks & hawks.

FIELDS & OPEN AREAS

BEAKS PART I

Birds use their bills to: ① gather & eat food; ② build nests; ③ fight & defend themselves; ④ climb & walk. But the beak's most important job is feeding. Get to know the basic beak types & you will understand the hunting habits of many birds.

◄ **HOOK**: Hawks, falcons & owls tear up prey with their powerful, hooked beaks.

▶ **SPEAR**: Herons, egrets, terns & kingfishers spear & hold fish with their long, straight beaks.

◄ **CHISEL**: Woodpeckers use these stout bills to drill into wood for boring insects.

▶ **PROBER**: Nuthatches & creepers use slender bills to pluck insects from bark. Hummingbirds withdraw nectar from tubular flowers. Sandpipers probe sand & mudflats.

◄ **CRACKER**: Grosbeaks, finches & sparrows crunch shells of seeds with their thick, cone-shaped bills.

114 BIRDLIFE

BEAKS PART II

▶ **HOOK & POUCH:** Pelicans net fish in their elastic throat pouch. The hook on the beak tip locks in squirming prey.

◀ **SKIMMING:** Black skimmers cut the water surface with an elongated lower mandible to catch fish.

▶ **SAW-TOOTHED:** Mergansers & cormorants hold slippery fish in the serrated margins of their beaks.

◀ **STRAINER:** The beaks of flamingos & dabbling ducks have comb-like strainer plates for filtering bottom debris from pulled up plants & shellfish.

▶ **BRISTLED:** Nighthawks, whip-poor-wills, chuck-will's-widows & flycatchers use rictal bristles by the mouth to trap insects in flight.

FIELDS & OPEN AREAS 115

FEET

Birds' legs & toes are adapted to serve four functions: ① movement; ② food gathering; ③ stability (perching, standing or floating; ④ preening. Below are shown six basic types of feet represented by avians in our area.

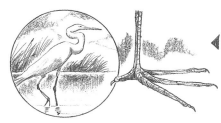

▸ **WADING**: Long extended toes lend stability when herons, egrets, ibises, sandpipers, plovers & rails traipse in mud & marsh vegetation to hunt.

▸ **SWIMMING**: Ducks, cormorants, loons & gulls use three or four webbed toes as paddles for swimming or diving.

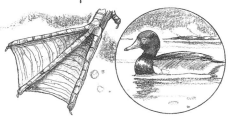

▸ **CLIMBING-CLINGING**: Woodpeckers hang in a verticle stance by grasping trees with two claws pointing forward & two claws pointing backward.

▸ **PERCHING**: Songbirds clutch even the springiest of branches with three forward toes & one elongated hind toe.

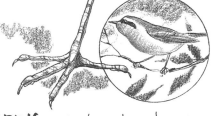

▸ **GRASPING**: Eagles, hawks & owls carry prey with their razor-sharp talons which pierce & crush skin & bones.

▸ **SCRATCHING**: Turkeys, pheasants & quail run & scratch food from the soil with their strong forward toes.

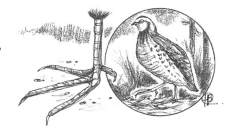

FIELDS & OPEN AREAS

Chapter 4

Woods Edge, Brush, & Second Growth

Colaptes auratus
Common Permanent

NORTHERN FLICKER

Swooping overhead in roller-coaster ascents & dips, this woodpecker displays why it is also known as the yellow-shafted flicker. Feathers of the underwings & inner tail glow golden hues when spread for flight. Upper body plumage is easy to know, too. A red nape crescent marks the gray crown. Cheeks are brown, & on males are streaked by a black moustache. The black-barred, brown back blends into a white rump patch, then into black tail feathers. Collared by black, tawny underparts are dark-spotted. Size: 12-14" (the flicker is our second largest local woodpecker).

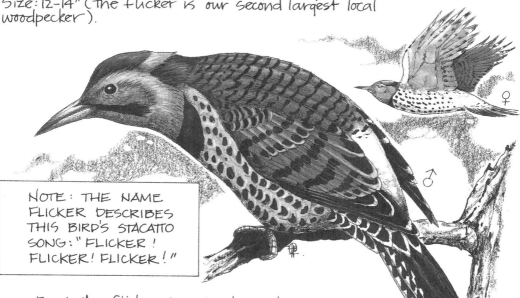

NOTE: THE NAME FLICKER DESCRIBES THIS BIRD'S STACATTO SONG: "FLICKER! FLICKER! FLICKER!"

Find the flicker in mixed woods, turned-over pine brakes, farm fields, gardens & lawnscapes. Spring-summer, it hops clumsily on the ground, ambushing ants & other insects by using its sticky tongue that strikes out 2" beyond the bill. Over winter, flicker flocks forage berries including poison ivy, blackgum, Virginia creeper, greenbrier & bayberry.

Wide-ranging common flickers breed from Florida to Newfoundland's treeline, west to central Alaska. Moustachioed males hammer a rap-tap tune of love on T.V. antennas, tin roofs & resonant limbs to woo mates. Pairs chisel a chamber in a dead hardwood for 6-8 white eggs. After feeding their young regurgitated bugs for a month, parents beak-peck fledglings out of the nest.

WOODS EDGE, BRUSH, & SECOND GROWTH

Vireo griseus
Permanent

WHITE-EYED VIREO

Often heard but seldom seen, the white-eyed vireo is a secretive songster of mixed woods, palm scrub & bottomland thickets. Identify it by its rise & fall voice, "chick-er-per-peeoo-chick'," punctuated on the last syllable. Flitting branch to branch & protectively adorned with greens above & grays below, this 5" vireo defies visual recognition. The bird's eponym white iris is ringed by yellow "spectacles". Yellow also washes its sides. Note two light wingbars.

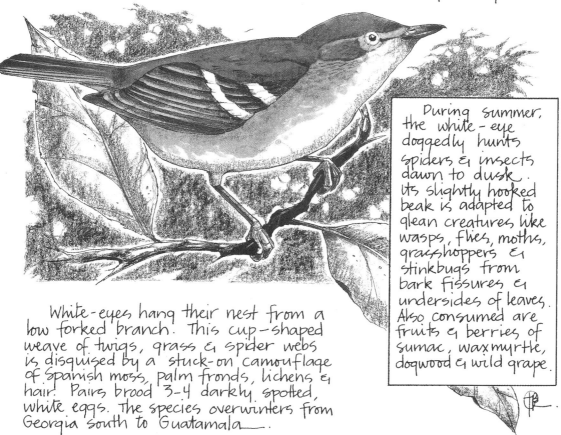

White-eyes hang their nest from a low forked branch. This cup-shaped weave of twigs, grass & spider webs is disguised by a stuck-on camouflage of Spanish moss, palm fronds, lichens & hair. Pairs brood 3-4 darkly spotted, white eggs. The species overwinters from Georgia south to Guatamala.

During summer, the white-eye doggedly hunts spiders & insects dawn to dusk. Its slightly hooked beak is adapted to glean creatures like wasps, flies, moths, grasshoppers & stinkbugs from bark fissures & undersides of leaves. Also consumed are fruits & berries of sumac, waxmyrtle, dogwood & wild grape.

WOODS EDGE, BRUSH, & SECOND GROWTH

Turdus migratorius
Winter

AMERICAN ROBIN

Berries and bugs bring American robins south for the winter. Their scattered flocks rove our hammocks, forests, and swamps where they gobble wild fruits and insects. Over three-fifths of their menu here consists of beak-sized berries: cabbage palmetto, blackgum, hollies, beautyberry, chinaberry, sumac, and red-cedar. By April these thrushes invade golf courses, lawns, pastures, and orchards. Here they run in stop-and-start spurts and appear to listen to the grass before stabbing the turf for buried earthworms or caterpillars and beetles.

Any schoolchild can recite the colors of "robin redbreast." The male shows a rust-red chest and belly, white and black throat streaking, and coal gray on the head, back, and tail. The female appears grayer. Birdwatchers should note *all* plumage is dulled on both sexes over the winter. Size: 9 up to 11 in.

One of the most widespread eastern North American avians, robins breed from Georgia to the timber line in Canada. Mates make nests on low limbs, fence posts or barn beams and window ledges. Their stick and grass platform is plastered with mud and plant fibers and is insulated with soft grass and feathers. Two or three clutches of three to four "robin's egg blue" eggs hatch by June. The spot-bellied fledglings can fly at just ten days of age.

AMERICAN ROBIN

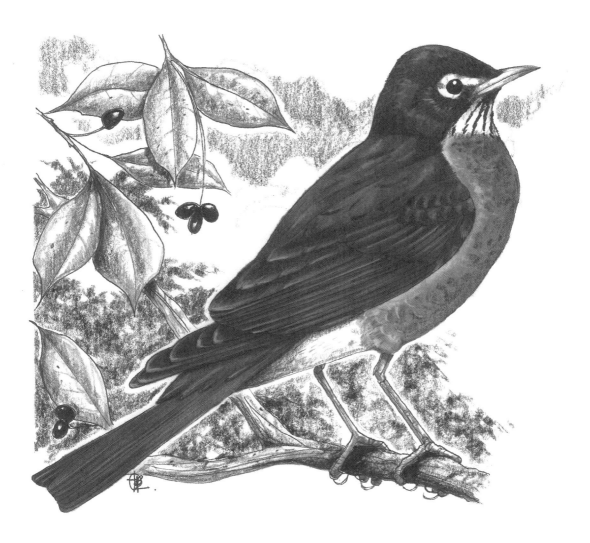

WOODS EDGE, BRUSH, & SECOND GROWTH

Bombycilla cedrorum
Winter

CEDAR WAXWING

Sleek, crested & black masked, the cedar waxwing (7") is named for the odd red tips on its secondary feathers. Ornithologists are puzzled by what function these waxy appendeges play. Perhaps they provide protective coloration when this olive-brown bird is feeding amid red berries. Note the yellow tail band is another excellent fieldmark.

Waxwings normally migrate through our area in March & November. Flocks of 30-50 birds wheel & soar in tight formations & alight in woodlands, gardens or landscaping to eat berries. 90% of their diet is fleshy fruits — like mistletoe, privet, persimmon, holly, grape & pyracantha. At perch, they are known to pass a single berry from one bird to another. Apparently the ceremony is an example of avian etiquette. Listen for their lisping, "zee, zee, zee," voices, uttered in flight.

Along the East Coast, cedar waxwings nest north of the Chesapeake Bay. They breed as late as June because they dawdle in the Carolinas while berry crops flourish. 2 broods of 3 to 5 young are fed fruit which the parent stores in its crop & disgorges one by one.

WOODS EDGE, BRUSH, & SECOND GROWTH

SEED·EATERS

Those of us who enjoy attracting birds to our backyard feeders do not have to be reminded how much they savor seeds. Protein-rich & loaded with vitamins, grains are a prime food source nutritionally. In late summer & fall, seed-eaters or granivores annually devour millions of pounds of weed seed & waste grain left in fields following harvesting. Biologists disagree whether avian appetites control weed populations or in fact thin-out seed placement so stronger plants survive.

SPARROWS ARE WELL-KNOWN GRANIVORES. THEY CRACK APART SEEDS WITH THEIR STOUT, CONICAL BILLS.

So, does the yellow-shafted flicker (left) eliminate noxious poison ivy by gulping the berries or does it really sow new growth in its seeded droppings? Cedar waxwings (right, below) do deserve credit for planting eastern redcedar hedgerows from their fencepost perches. These groves shelter wildlife & serve as windbreaks.

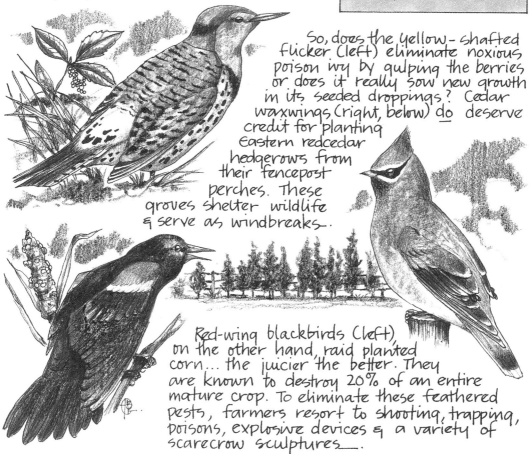

Red-wing blackbirds (left), on the other hand, raid planted corn... the juicier the better. They are known to destroy 20% of an entire mature crop. To eliminate these feathered pests, farmers resort to shooting, trapping, poisons, explosive devices & a variety of scarecrow sculptures.

WOODS EDGE, BRUSH, & SECOND GROWTH

Spinus tristis
Winter

AMERICAN GOLDFINCH

When the goldfinches flock through our region in late February, you may be sure spring is just around the corner. Swooping through the sky in roller-coaster arcs, they teem to fields, meadows, pond shores, bushes & forest edges sprouting showy first weed crops. Thistle*, dandelion, ragweed, shepard's-purse & goldenrod are attacked for their seeds! These finches gang up on one stalk until the corolla bends to the ground. Using their stout cone-bills, they will neatly hull the seeds' hard husks & extract the meat.

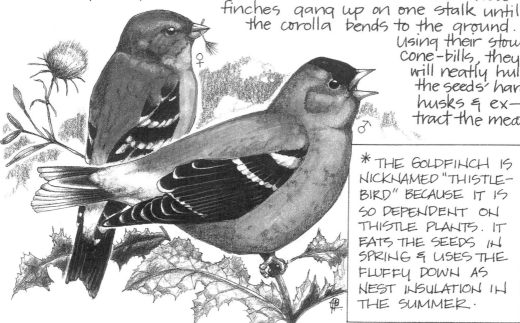

* THE GOLDFINCH IS NICKNAMED "THISTLE-BIRD" BECAUSE IT IS SO DEPENDENT ON THISTLE PLANTS. IT EATS THE SEEDS IN SPRING & USES THE FLUFFY DOWN AS NEST INSULATION IN THE SUMMER.

By spring migration the male goldfinch wears its namesake plumage. Its canary-yellow body contrasts a black cap, wings & tail. The capless female is olive-yellow & shows white wingbars. Over winter both sexes (5") look like a brownish female.

From central Virginia through Maine goldfinches nest in tree groves, hedges & even sturdy cornstalks or thistles. They braid an air-tight cup of grass softened with corn silk & thistle-down. Heralding, "per-chic-o-ree," the male bodyguards his mate incubating 4-6 pale blue eggs. Young are reared 2 weeks on regurgitated seeds & insects foraged from nearby fields___.

WOODS EDGE, BRUSH, & SECOND GROWTH

Pipilo erythrophthalmus
Common Permanent

EASTERN TOWHEE

Trail walkers who trek our brushy woodlands and palm thickets may mistake the noisemaking antics of the Eastern towhee for the scurrying of a snake or mammal. This "ground robin" rummages in the understory debris to feed. By hopping on alternate feet, it flips up leaf litter and uncovers a treasure trove of plants and animals overlooked by other foraging birds. In the summer it devours beetles and their larvae, caterpillars, grasshoppers, crickets, wasps, spiders, and snails. Autumn through spring, fruits (bayberry, blackberry, sumac, blueberry), acorns, and seeds (grass, ragweed) are harvested. The male towhee shows a black head, chest, and back. These parts are brown on the female for camouflage. The white belly is streaked with rust brown on the flanks. End and outer tail feathers are white. Size: 7 up to 8½ in.

April to May, Eastern towhees nest in saw palmetto fronds or low shrubs less than 4 ft. above ground. They weave dry leaves, pine straw, rootlets, and plant fiber into a deep cup-nest. Their three to four white eggs are specked with cinnamon brown. Up to three clutches are hatched each season because eggs and young are so easily lost to snakes, small mammals, and parasitic cowbirds.

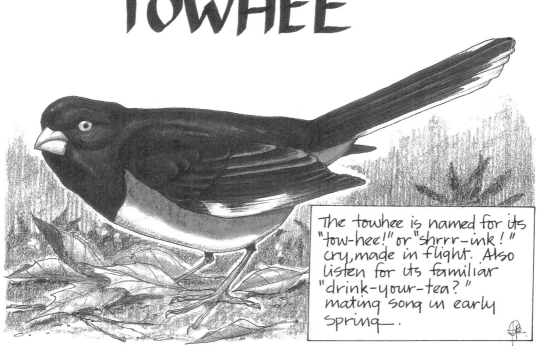

The towhee is named for its "tow-hee!" or "shrrr-ink!" cry, made in flight. Also listen for its familiar "drink-your-tea?" mating song in early spring.

Melospiza melodia
Common Winter

SONG SPARROW

This shy winter visitor typically perches secluded in thick shrub-growth bordering marshlands, ditches, roads & homesites. Its warm, brown plumage blends perfectly with nearby foliage. Heavy streaks on the breast form a large, central spot. The song sparrow ventures out to open edges to feed. Autumn's rich harvest of seeds... smartweed, ragweed, dock, pigweed, wild grasses & sedges... comprise 86% of the bird's diet. Crickets, beetles, grasshoppers & ants are also gleaned from grasslands. In flight, song sparrows commonly pump their tails____.

Here in the East, song sparrows breed from the Ohio River Valley, north to the lower Hudson Bay. They nest on the ground. Their streaked coloration protects parents & their 4-5 chicks against predator raccoons, squirrels & foxes____.

WOODS EDGE, BRUSH, & SECOND GROWTH 135

Junco hyemalis
Common Winter

DARK-EYED JUNCO

This cold-loving sparrow is driven to migrate south only when bone-numbing squalls bluster down from the Arctic. It has earned the nickname "snowbird" because it is so adept at excavating seeds (weed, tree, grass) and burrowed insects or spiders from frosted leaf litter and ice banks. Its family name, junco, is derived from the Spanish word for rush, a plant which sheds the seeds this sparrow eats. The dark-eyed junco is one of at least a dozen species of junco found in North America.

Inhabiting mixed forests, brush growth, field margins, and feeders south to the Everglades, this junco is easy to know. No other sparrow wears charcoal gray on the head, breast, and upper parts. The beak, belly, and outer tail feathers are white. Plumage on the female is tinted with brown. Size: 5½ up to 6¾ in.

In the East, breeding "snowbirds" range from Georgia's Appalachians north to Labrador. Their deep bowl nest of grass, moss, shredded bark, fur, and feathers is nestled in rock crevices or exposed roots. The four to five pale green eggs are brown-specked.

DARK-EYED JUNCO

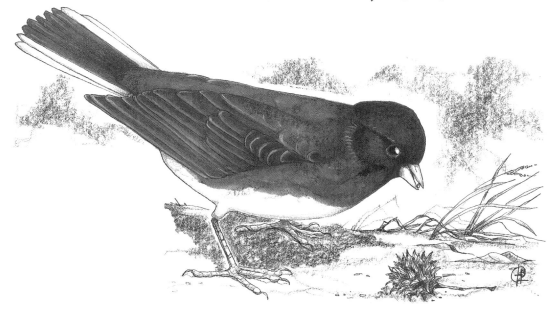

WOODS EDGE, BRUSH, & SECOND GROWTH

Icteria virens
Summer

YELLOW-BREASTED CHAT

Like comics who crack their best one-liners backstage, the yellow-breasted chat cavorts and croons behind a briar patch curtain where few birdwatchers may enjoy the show. Damp and tangled thickets shelter this shy vocalist. It "chats" a medley of mews, cackles, and whistles while flitting from vine to branch. Flights are erratic and amusing to see. The chat flaps aloft, dangles its legs and pumps its long tail. No highflier, it is bent on devouring forest floor insects, spiders, and berries.

Olive brown above, the chat is bathed in yellow on its neck and breast. White "eyeglasses" highlight the eyes. It measures up to 7 in. in length. The nestbuilding chat intertwines grass, weed stems, bark strips, and leaves amid thorny shrubs. Here are brooded three to five pinkish-white spotted eggs.

YELLOW-BREASTED CHAT

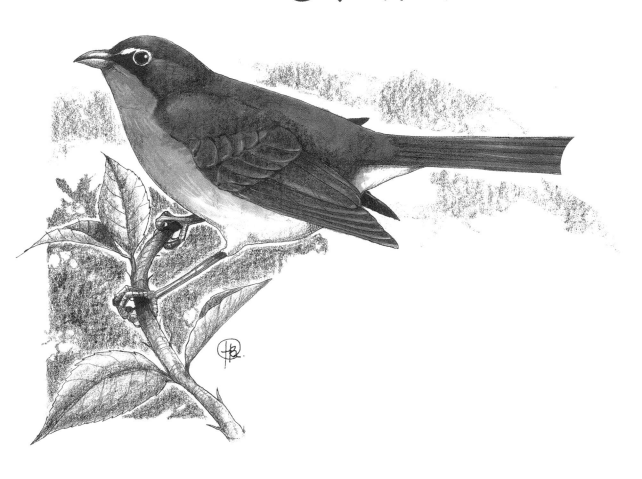

WOODS EDGE, BRUSH, & SECOND GROWTH

Setophaga palmarum
Winter

PALM WARBLER

If nicknames were allowed by ornithological pundits, then "wag-tail warbler" would be this bird's just title. You'll easily identify the ground-loving palm warbler by its non-stop, up & down tail-tipping. Its winter plumage is olive-brown above, streaked yellow below. The rump & undertail coverts are yellow. By spring its cap turns rust-red & contrasts with a palish eye stripe. Size: 4½ - 5½".

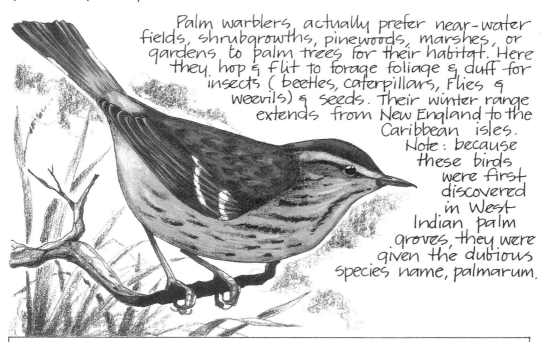

Palm warblers actually prefer near-water fields, shrubgrowths, pinewoods, marshes, or gardens to palm trees for their habitat. Here they hop & flit to forage foliage & duff for insects (beetles, caterpillars, flies & weevils) & seeds. Their winter range extends from New England to the Caribbean isles.
Note: because these birds were first discovered in West Indian palm groves, they were given the dubious species name, palmarum.

No shimmering, green fronds wave where "wag-tails" breed. They migrate to the Muskeg (sphagnum bog) region found from northern Maine to Minnesota, & north throughout Canada to 55° N. Latitude. Concealed in high vegetation, the nest of grass, moss & bark strips cradles 4-5 brown-blotched white eggs.

WOODS EDGE, BRUSH, & SECOND GROWTH

Setophaga discolor
Summer*

PRAIRIE WARBLER

Don't expect this active songster to show up on prairies, despite its name. The prairie warbler is common to low-hanging pine limbs, mixed woods margins, brushlands & saplings that reclaim grasslands or burned/clear-cut forests. It is highlighted by yellow underparts broken with black stripes on the sides, & by a black mustache & eyeline. Chestnut flecks the male's olive back; females lack any markings. In winter the distinguishing stripes fade on both sexes. Size: 5".

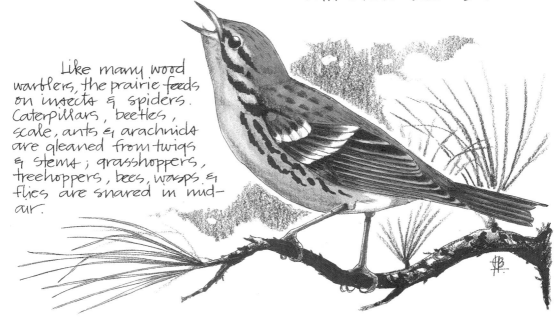

Like many wood warblers, the prairie feeds on insects & spiders. Caterpillars, beetles, scale, ants & arachnids are gleaned from twigs & stems; grasshoppers, treehoppers, bees, wasps & flies are snared in mid-air.

Flicking its tail, thrusting its black bill upwards, the prairie warbler sings an ascending, buzzy "zee-zee-zee-zee-zee." This trill... once compared to "a mouse complaining of a toothache"... is the male's claim to nesting territory. Branches below, his mate incubates four greenish-white, spotted eggs in a woven bowl of grass, weeds, Spanish moss, bark strips, hair & twine. * Note: Prairie warblers normally overwinter from Florida to Central America but are known to linger year-round as far north as South Carolina.

WOODS EDGE, BRUSH, & SECOND GROWTH

Passerina caerulea
Summer

BLUE GROSBEAK

Quick, warbled phrases that soar & descend in pitch & terminate with "chink" are callnote clues to the blue grosbeak's whereabouts. The 6-7½" cardinal's cousin hides away in underbrush, unkempt road shoulders & shrubby pond margins. Masked in shadelight, it appears blackish like a cowbird. Only in bright sun is the male's rich plumage revealed. His body is glossy, royal blue; 2 bars on the wing coverts are chestnut & tan; the stout bill is misty blue. Protectively colored for her incubating duty, the female is cinnamon-brown above, tawny below; her wingbars are tan & her beak is dirty white.

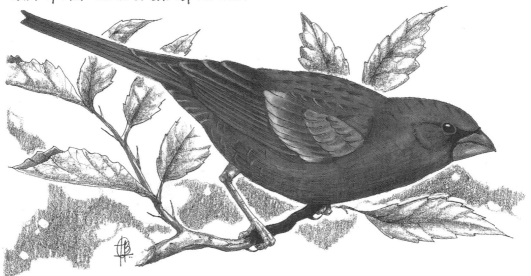

Summer's snarled network of brambles, along with orchard & hardwood limbs (to 30 ft. high) provide safe cover for breeding "blue pops". Mates twine a cupped nest from grass, leaves, plant cellulose, rootlets & hair. A recycled snakeskin is typically a trademark addition to the home. The 3-4 eggs are unspotted, pastel blue. Both parents ply the mottled, brown & blue hatchlings with mouthfuls of insects. Weevils, grasshoppers, caterpillars, cutworms, locusts, beetles & bugs... generally considered pests by farmers... comprise a high percentage of this grosbeak's diet. In route to their winter quarters in Cuba & Central America, migrant blues feed on wild grass, oats & rice.

WOODS EDGE, BRUSH, & SECOND GROWTH

Passerina cyanea
Summer

INDIGO BUNTING

Bluebird lovers, you haven't really seen blue until you've met the indigo bunting (5½"). The male displays rich, ultramarine body plumage...like the hue of deep tropic seas... with black highlighting the wings & tail. He is heard & seen crooning his late summer's song, "sweet-sweet, here-here" in soprano, double-note phrases from power lines or branchtop perches. Harder to watch are his feeding habits. This "blue canary" raids insects under the cover of shrubby woods borders, unkempt pastures & burnt fields. Here he hunts canker-worms, beetles, chafers, true bugs & grasshoppers.

NOTE: "BUNTING" MEANS PLUMP, LIKE THE STOUT BODY OF THIS FINCH.

What about the female indigo? Mousy brown above, faintly streaked on her beige belly, she secrets her summers with nesting chores. Her drab colors provide camouflage while she incubates 3-4 pale blue eggs in cupped grass, weed stems & browned leaves. The male caters insects to its brooding mate. After the young buntings fledge, the female constructs a new nest in ferns & low shrubs, & lays a second clutch. Now the male indigo is most visible & loudest in voice: its brilliant blues & high tune decoy predators & warn competing males away from the family. Fall flocks feed on berries, weed seeds & farmed grains when they migrate to Mexico, Panama & the West Indies for the winter.

WOODS EDGE, BRUSH, & SECOND GROWTH 147

Chapter 5

Forests

Coccyzus americanus
Summer

YELLOW-BILLED CUCKOO

Croaking a gutteral "ca-ca-ca-cow-cow-cow" song, the yellow-billed cuckoo hides in dense woodlands fettered with labyrinths of tangled vines. Here it forages caterpillars, katydids, grasshoppers, beetles & sawfly larvae... pests which defoliate shade & orchard trees. Highly savored in the cuckoo's cuisine are hairy caterpillars which are avoided by other bug-eating birds. Three adaptations enable the yellow-bill to hunt hard-to-get insects: ① a long, decurved beak for gleaning prey from leaves; ② a slender body for fitting into tight quarters; ③ 2 forward & 2 rear toes to lend stability on the perch.

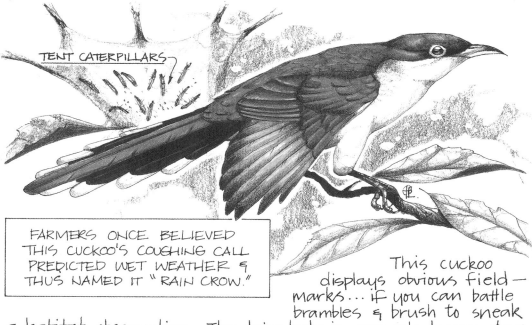

FARMERS ONCE BELIEVED THIS CUCKOO'S COUGHING CALL PREDICTED WET WEATHER & THUS NAMED IT "RAIN CROW."

This cuckoo displays obvious field-marks... if you can battle brambles & brush to sneak a habitat observation. The trim body is grayish-brown above, white below. Large white spots decorate the long black tail. The bird is named after the yellow lower bill mandible. Rusty wing patches show in flight. Size: 11-13".

By May yellow-bills pile up platform nests of twigs chinked with willow catkins, leaves & moss between "V" limbs. The 3-5 eggs are pale aqua-green. Parents are devoted brooders & do not lay their clutch in the nests of other birds as do their Old World cousins___.

FORESTS

Zenaida macroura
Common Summer

CHUCK-WILL'S-WIDOW

Anyone who has ever been startled awake on early spring evenings by "ch'k-will's-wid'ow!" echoed repeatedly from nearby woods knows this bird firsthand. March through July it yells its mating call. Mottled, spotted, and barred with brown and black, the up-to-12-in. Chuck-will's-widow blends with shadows and dry foliage in its pine grove or hammock home. It hunts at night like a feathered bat, capturing insects (moths, beetles, roaches, Maybugs, pine borers) on the wing. Stiff bristles growing around its gaping, 2-in.-wide mouth help to net prey. Even unsuspecting sparrows and hummingbirds are gulped down during nocturnal food forays. Strong-winged but weak-footed, the Chuck-will's-widow nestles quietly on the shaded forest floor during daylight hours. Here it lays two cream-colored eggs with brown and lilac spatterings. During nesting season, all singing ceases. Hatchlings are covered with down until they fledge flight feathers. Over winter, this bird migrates as far south as Colombia, South America.

Note: The Chuck-will's-widow belongs to the Goatsucker order. European legend, the origin of their name, says these birds milked goats. Do you "swallow" this superstition?

CHUCK·WILL'S·WIDOW

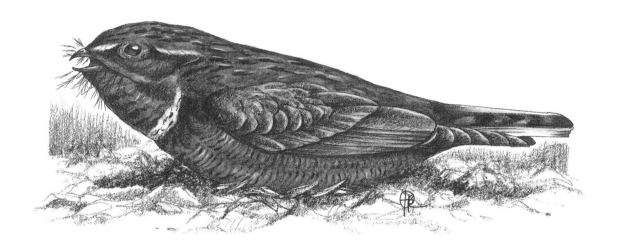

FORESTS 153

Elanoides forficatus
Endangered

SWALLOW-TAILED KITE

The few remaining barrier islands on which are preserved forested swamps, marshes & hammocks are the best habitats to view the graceful swallow-tailed kite. Know the bird by its white head & underparts, contrasting with black wings, back & a deeply forked tail. It is named for this 8" tail & for its hunting habits. Soaring & gliding across wetland skies, the swallow-tail does not dive for prey. Instead, it drops feet-first into undergrowth, captures snakes, lizards, frogs or insects in its stout talons, & swoops heavenward. Food is devoured on-the-wing. This entire manuever is called "Kiting".

These kites nest in pinnacles of swamp-land hardwoods. In early spring, 2 to 4 chestnut, spotted eggs are incubated in a bed of sticks, twigs, dried grass & moss. By Autumn, swallow-tails will migrate south through Florida & Central America.

FORESTS 155

Accipiter cooperii
Permanent

COOPER'S HAWK

The Cooper's hawk is slate blue above and white below, with rust red striping its underparts. It is distinguished from its near twin, the sharp-shinned hawk, by its round tail and its larger size (15 up to 20 in.). In the air, the Cooper's hawk shows short wings and a long tail, and flies in a flap and glide pattern. It is a stealthy predator which hunts in open woods and forest edges, where it also nests. It consumes a wide variety of medium-size birds and some mammals.

Annually, Cooper's hawks return to their same tree fork nests, up to 60 ft. high. New twigs, bark strips, leaves, and moss are stuffed in the roost until it grows bulky. Eggs: three to four spotted blue or greenish white.

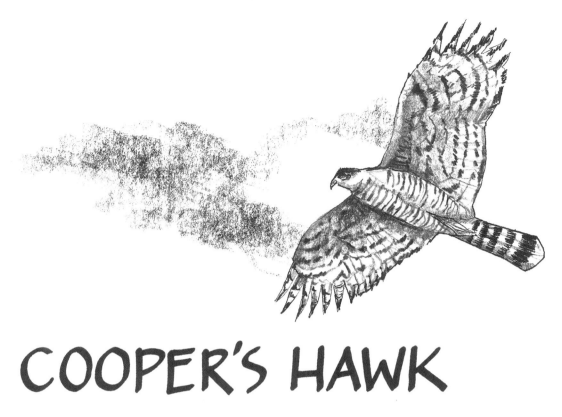

COOPER'S HAWK

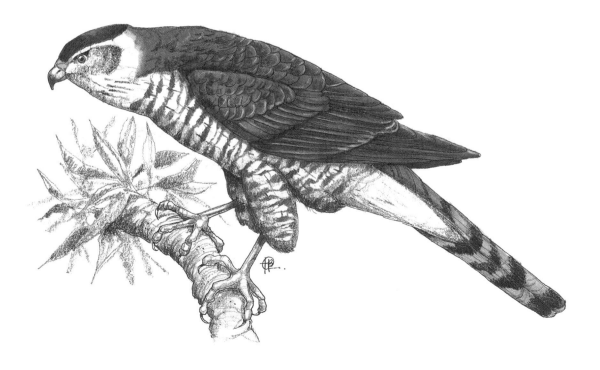

Melanerpes carolinus
Common Permanent

RED-BELLIED WOODPECKER

This woodpecker is named "zebra" for its black & white barred back. No other bird of its family wears such stripes along with red on the head. The male's entire forehead & nape (hind neck) is scarlet. On the female just the nape is colored. A rose wash tints the gray-buff belly, but is evidenced only at close range. Size: 9-10".

Nervous noisemaker in woods, hammocks, swamp forests, wetlands & towns, the red-belly is an energetic songster & hunter. Its broken-record tremelo, "tchurr, tchurr, tchurr...," is a familiar bird song borne on spring winds. Acorns, & fruit (grape, cherry, blackgum, bayberry, Virginia creeper, palmetto, mulberry, poison ivy) & corn comprise 2/3 of the diet. In Florida, decaying, ripe oranges are pecked for fermenting pulp. Insects, insect eggs (including cockroaches), tree frogs & lizards are summer's protein sources.

Drumming their beat of love, red-bellies court one-another by hammering hollow timber with their beaks. Pairs excavate a neat burrow in dead trees & palmetto stubs, 5 to 60 feet up. May-June, 5-6 young hatch in 2 weeks from glossy-white eggs.

FORESTS 159

Sphyrapicus varius
Common Winter

YELLOW-BELLIED SAPSUCKER

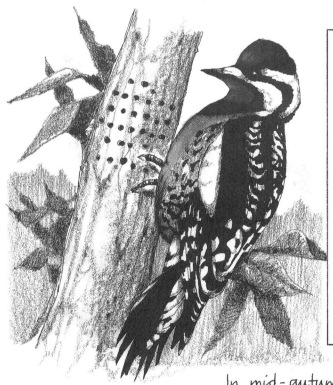

Rogue of the woodpecker family, the yellow-bellied sapsucker is named for its unique feeding habit. The bird drills rows of evenly spaced holes which are deep enough (½-¾") to invade the soft cambrium layer of hardwood & pine trees. It inserts its specialized tongue with a fleshy brush at the tip to withdraw sap & wood fibers. If these borings girdle the tree, it will die. Ants & beetles attracted to the seeping sap wells, along with caterpillars, spiders & fruits are also consumed.

In mid-autumn, yellow-bellies wander into our region. Most inhabit pinewoods, mixed oak-maple-magnolia-gum forests, swamps & hammocks. They may be traced by their mewing, squealing calls. Both sexes (8-9") show a red forehead, black upper parts barred with white & an obvious white wing patch. The throat on males is red; on females, white. Light yellow tints the male's belly near springtime. By April, sapsuckers migrate north of Connecticut to the Appalachians to nest. 3 to 7 white eggs are brooded 40 ft. above ground in standing, deadwood trunks.

FORESTS 161

Dryocopus pileatus
Common Permanent

PILEATED WOODPECKER

When birdwatchers visit the sea islands, the pileated woodpecker is one bird they eagerly stalk. See this "Great God Woodpecker" for yourself... you'll understand why. This species is over 17" long, & its all-black back, flame-red crest (females foreheads are black), & white eye, cheek, neck & throat stripes are unmistakable. Listen for its hyena-like voice... a laughing "kik-kik-kik" series... if you visit mixed woods, deciduous forests or palmetto hammocks in our area. There the big-beaked pileated chisels large oblong holes with drumming sounds that echo across the timberlands. It feeds on ants & borer beetles, which it impales with its long, sharp-tipped tongue. Other food includes wild fruits & berries.

NOTE: THE NAME PILEATED IS GENERALLY PRONOUNCED pī-lē-ā'-tĭd, & MEANS "HAVING A PILEUS OR CREST."

Pileateds excavate 3 foot deep nest cavities in deadwood or live trees to 75 feet elevations. The wood chips inside cushion 3-5 glossy-white eggs. Youngsters are identified by short "crew-cut" crests. Abandoned borings are used by other burrow-nesting avians like kestrels, screech owls & wood ducks... a prime example of how space is never wasted in Nature.

FORESTS **163**

A BIRD FOR EVERY BUG

PART I

April through September, insects seem to swarm, swim, creep & dig everywhere. Their life cycle peaks during summer. But it just so happens this population explosion coincides with bird nesting season. Always available, easy-to-catch bugs are now most birds' main food source. Notice how so many winged exterminators have evolved such distinct hunting techniques or niches.

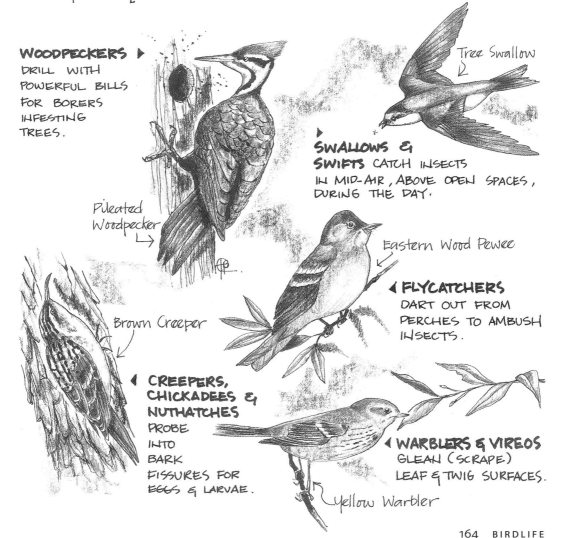

WOODPECKERS ▶ DRILL WITH POWERFUL BILLS FOR BORERS INFESTING TREES.

Pileated Woodpecker

Tree Swallow

▶ **SWALLOWS & SWIFTS** CATCH INSECTS IN MID-AIR, ABOVE OPEN SPACES, DURING THE DAY.

Eastern Wood Pewee

◀ **FLYCATCHERS** DART OUT FROM PERCHES TO AMBUSH INSECTS.

Brown Creeper

◀ **CREEPERS, CHICKADEES & NUTHATCHES** PROBE INTO BARK FISSURES FOR EGGS & LARVAE.

◀ **WARBLERS & VIREOS** GLEAN (SCRAPE) LEAF & TWIG SURFACES.

Yellow Warbler

164 BIRDLIFE

A BIRD FOR EVERY BUG
PART II

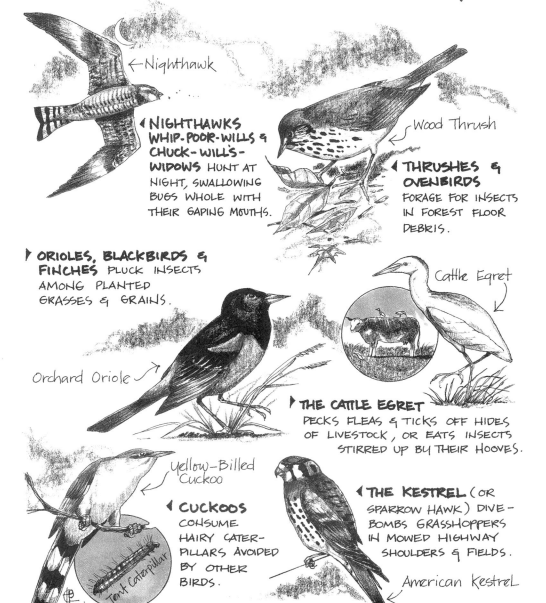

← Nighthawk

◀ **NIGHTHAWKS, WHIP-POOR-WILLS & CHUCK-WILL'S-WIDOWS** HUNT AT NIGHT, SWALLOWING BUGS WHOLE WITH THEIR GAPING MOUTHS.

← Wood Thrush

◀ **THRUSHES & OVENBIRDS** FORAGE FOR INSECTS IN FOREST FLOOR DEBRIS.

▶ **ORIOLES, BLACKBIRDS & FINCHES** PLUCK INSECTS AMONG PLANTED GRASSES & GRAINS.

Orchard Oriole →

Cattle Egret ↓

▶ **THE CATTLE EGRET** PECKS FLEAS & TICKS OFF HIDES OF LIVESTOCK, OR EATS INSECTS STIRRED UP BY THEIR HOOVES.

Yellow-Billed Cuckoo →

◀ **CUCKOOS** CONSUME HAIRY CATERPILLARS AVOIDED BY OTHER BIRDS.

Tent Caterpillar

◀ **THE KESTREL** (OR SPARROW HAWK) DIVE-BOMBS GRASSHOPPERS IN MOWED HIGHWAY SHOULDERS & FIELDS.

American Kestrel ↙

FORESTS 165

Contopus virens
Common Summer

EASTERN WOOD-PEWEE

A hiker could pass inches away from an eastern wood-pewee and never know it. Olive gray above, light grey below, the sparrow-sized flycatcher blends into the dappled shadows of its deep domicile. Its white speculum and yellow lower mandible distinguish it from its cousin, phoebe. The bird is most easily recognized by its plaintive whistle, "pee-a-wee," falling in scale.

A pewee's hunting technique is like a bird-sized Blitzkrieg. It darts out of its leaved hideaway, slams closed its slightly hooked bill on insects, spiders, and millipedes, then wings back to its perch to savor the mouthful. A high percentage of its diet are pests like flies or wood-boring beetles.

The female pewee is a camouflage queen when it comes to pasting together a nest. She saddles a bowl of fine grass, bark strips, and plant fibers on a bare limb, 10 to 60 ft. high. Next she crochets a fuzzy felt of lichens and cobwebs which perfectly simulates the tree bark. She broods two to four cream-white eggs wreathed with earthen colors at the large end. Eastern wood-pewees overwinter from Costa Rica to Peru.

EASTERN WOOD-PEWEE

FORESTS

Cyanocitta cristata
Common Permanent

BLUE JAY

Everyone knows the blue jay for its showy colors and bold personality. Crested and royal blue above, the jay displays white patches on the wings and tail. Pale white underparts are decorated by a black throat crescent. This noisemaker of oak and pine woods, marsh hammocks, swamp edges, and city shade trees commands attention with its harsh, shrieking "thief! thief!" Experts suggest the 11- to 12½-in. blue jay serves as sentry, warning other forest creatures about predators and intruding humans. The jay also mimics the red-shouldered hawk's "kee-yer!" to frighten off birds competing for food. Jays are most boisterous when they rove in families and migrant flocks in autumn, winging branch to branch.

Acorns, palmetto seeds, wild fruit, and grains comprise seventy-five percent of the jay's diet. But its large beak is well suited for hunting animals, including insects, mice, frogs, and even the eggs and young of small birds. Note: the environmental damage caused by the jay's nest-robbing is balanced by its consumption of harmful insects (grasshoppers, hairy caterpillars, wireworms, scale) and by the many new oak trees that sprout from the acorns it buries.

March to August, blue jays raise two broods of three to six hatchlings. Their greenish-brown eggs are incubated in nests of twigs, moss, pine straw, rootlets, bark, and scrounged yarn, cloth, etc., loosely built-in conifer branches to 35 ft. Parents will divebomb cats, snakes, owls, and noisy birdwatchers that stray too near their new family.

BLUE JAY

FORESTS 169

Baeolophus bicolor
Common Permanent

TUFTED TITMOUSE

If you give ear to the first bird songs of spring, you will recognize the clarion call, "peter, peter, peter," of the tufted titmouse. Small (6") & crested, slate-gray above with white underparts & rusty flanks, it lives in pine-oak woods & neighborhood shade trees. Here this active, acrobatic feeder flits among treetop limbs, inspecting boughs for food by peering under each leaf. Two-thirds of its diet is small insects & their eggs which are over-looked by larger birds. Many bugs like boll weevils, scale or caterpillars are pests to Man. The titmouse forages berries, seeds & acorns in Fall-Winter.

Titmice nest in holes found in fence posts or rotting conifers. They cushion the hollow with feathers, cotton, moss, leaves & bark strips. Fearless scavengers, the birds reportedly yank hair from the heads of humans when the homebuilding urge calls. An average clutch contains 5-6 creamy eggs spotted with reddish brown___.

FORESTS **171**

Certhia americana
Winter

BROWN CREEPER

Bark is a playground for the brown creeper. Here, hugging a hardwood trunk, shinning upwards in jerking spirals, the bird hunts insects. Using its slim, decurved beak to probe crevices, it extracts ants, beetles, scales, plant lice, caterpillars & insect eggs. Spiders & seasonal seeds are eaten occasionally. "Bottom-story" bugs seem to be the relished bill-of-fare. Once the brown creeper hikes mid-way up the timber, it lofts down to the foot of another bole to resume feeding.

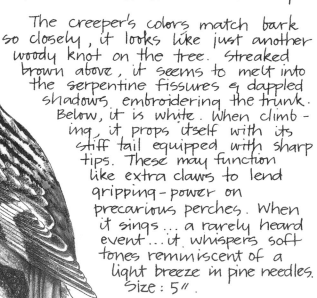

The creeper's colors match bark so closely, it looks like just another woody knot on the tree. Streaked brown above, it seems to melt into the serpentine fissures & dappled shadows embroidering the trunk. Below, it is white. When climbing, it props itself with its stiff tail equipped with sharp tips. These may function like extra claws to lend gripping-power on precarious perches. When it sings... a rarely heard event... it whispers soft tones reminiscent of a light breeze in pine needles. Size: 5".

The eastern U.S. breeding zone for brown creepers spans from the Hudson River estuary, New York northward, & in the Appalachian range south into Tennessee. These birds stuff their nests... twigs, down-like fibers, bark shreds & feathers... behind a hatch-cover of dislodged bark, normally in a balsam fir. Their 4-8 eggs are cream-white with speckles forming a ring at one end.

FORESTS 173

Regalus satrapa
Winter

GOLDEN-CROWNED KINGLET
REGALUS SATRAPA

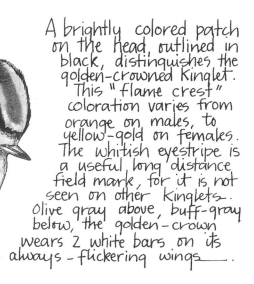

A brightly colored patch on the head, outlined in black, distinguishes the golden-crowned Kinglet. This "flame crest" coloration varies from orange on males, to yellow-gold on females. The whitish eyestripe is a useful long distance field mark, for it is not seen on other kinglets. Olive gray above, buff-gray below, the golden-crown wears 2 white bars on its always-flickering wings.

Island birdwatchers should stalk the winter pine woods, & should keep ears alert for this kinglet's high, "see-see-see" call, prior to sitings. It normally flits from branch to bough, probing needles & scaly bark for wasps, borer beetles, flies, plant lice or insect larvae & eggs. Its diet of damaging insects makes this tiny (3-4") bird a valuable agent in preserving coastal timberlands.

Nesting golden-crowned kinglets inhabit the cool climes & spruce forests along the Allegheny Mountains to Massachussets, New York & Labrador. Their moss-lined nests are concealed by a tent of collected bird feathers. This screen hides 5-10 eggs... a clutch so large that it must be laid in double layers to fit in the roost!

FORESTS 175

Corthylio calendula
Common Winter

RUBY-CROWNED KINGLET

Mixed pine-oak-gum woods provide a winter habitat for the ruby-crowned kinglet. Drab olive above, buff below, the bird is best known for a scarlet crown patch, displayed by the male. He flares this flame-red flag to intimidate rivals or to court a spring female. Both sexes show a broken white eye-ring, white bars on flicking wings, and a stubby tail. Locate this miniature musician (4 in.) by its larger-than-life melody, "tee-tee-tee, tew-tew-tew, li-ber-ty!"

Breeding season finds the ruby-crowned kinglet migrating to conifer forests from central Maine to Labrador. It compacts a cushiony cup nest of moss, bark strips, grass, cocoon silk, feathers, and hair at the far reach of a central limb. The five to nine white eggs are stained with brown specks at the larger end. Dull-headed hatchlings are catered bugs, beetles, wasps, plant lice, and insect eggs, ninety percent of the kinglet's year-round menu.

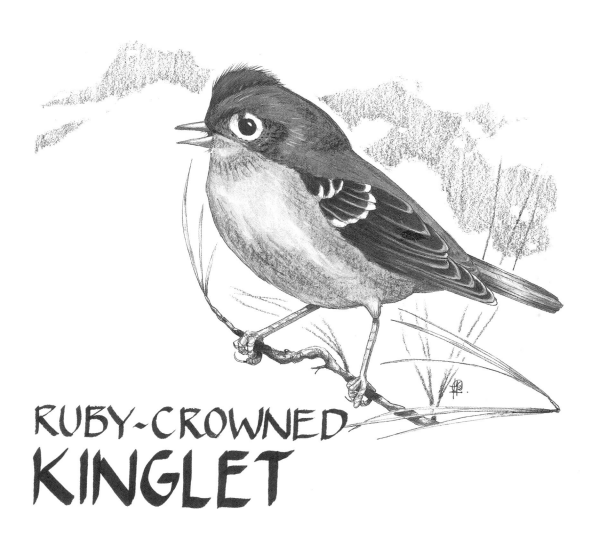

RUBY-CROWNED KINGLET

Catharus fuscescens
Transient

VEERY

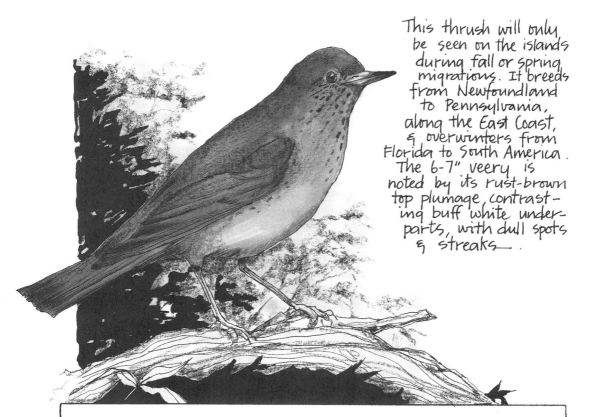

This thrush will only be seen on the islands during fall or spring migrations. It breeds from Newfoundland to Pennsylvania, along the East Coast, & overwinters from Florida to South America. The 6-7" veery is noted by its rust-brown top plumage, contrasting buff white underparts, with dull spots & streaks.

Typical of its family, the veery is a resident of the deep, often damp woods. Striding on long legs across the leaf & limb-strewn forest floor, it deftly hunts snails, worms & crawling insects from the debris. Low-hanging, wild fruits are also consumed from the vine. Its sweet summer song, a series of descending, "veero, veery, veery, veery" notes, names the bird. Here in the South, listen for its call, a hushed, "phew!", from November to March.

F. Bottontine

FORESTS 179

Catharus ustulatus
Transient

SWAINSON'S THRUSH

*Few birds rival the Swainson's thrush in distance covered on migrations. On the East Coast, the species is known to wing from the Hudson Bay area, south to Peru and Argentina... a roundtrip covering 10,000 miles!

The Swainson's thrush is an avian more common to the Catskill Mountains of New York, Pennsylvania & West Virginia, or to the Canadian spruce belts, than to the southern barrier isles. Only in April & October migrations will this bird be seen in our mixed pine-oak-gum forests. 7 inches in length, the Swainson's is distinguished from any other thrush by its buff-colored eye-ring. Amber tinting blushes the cheeks & spotted breast. The bird was once called the "olive-backed thrush", in reference to its greenish-brown upper plumage. Woodswalkers may scout low limbs, shrubby foliage & leaf litter for feeding Swainson's thrushes. They overturn twigs & ground "duff" with their long, stout bills when hunting insects, spiders, snails or worms. A bounty of fruits...wild cherry, Virginia creeper, elderberry & grape... are favored fare in fall.

FORESTS **181**

Catharus minimus
Transient

GRAY-CHEEKED THRUSH

This strong-winged tourist will only be seen on the islands in spring and fall. During brief migratory stopovers between Canada and South America, the gray-cheeked thrush will rummage shrubs and the hardwood forest floor for food. New populations of beetles, ants, sowbugs, caterpillars, and earthworms are consumed in springtime. The thrush's autumn appetite favors fruits or wild berries, including dogwood, blackgum, grape, or greenbriar. Grayish olive above, heavily spotted on its upper breast, this 7½-in. bird is identified by its buff-gray cheek patches and the lack of a noticeable eye-ring.

Along the East coast, the gray-cheeked thrush nests from Newfoundland to Labrador. Its nest, an interweave of dried bark strips, cushioned by moss and dead grass, is constructed in low, subalpine trees or bushes. Three to four young are raised each summer.

GRAY-CHEEKED THRUSH

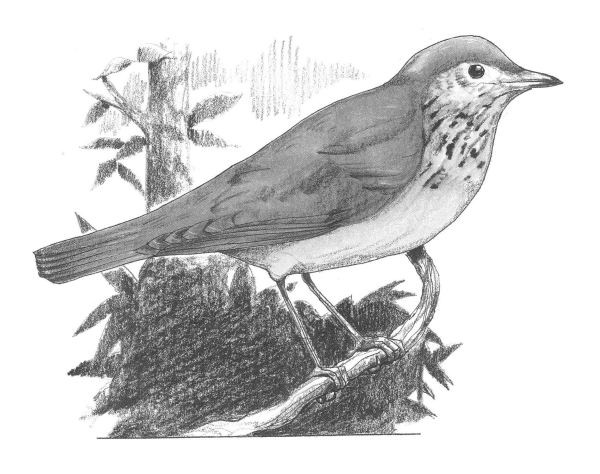

Hylocichla mustelina
Summer

WOOD THRUSH

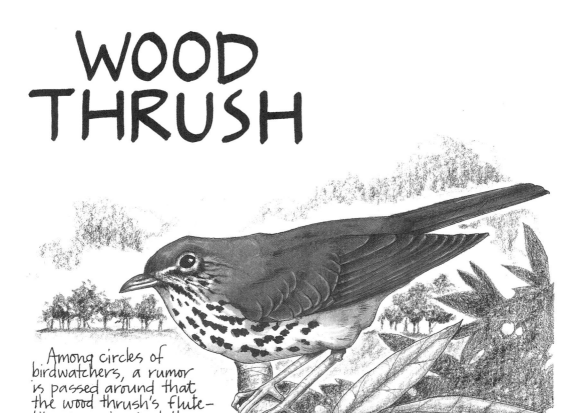

Among circles of birdwatchers, a rumor is passed around that the wood thrush's flute-like song inspired the melodies of French composer Gounod. At dawn & dusk, we too may enjoy its sweet song, "ee-oh-lee... ee-oh-lay".

The 8" chorister abides in shady woods with water nearby. Here it consumes insects (grasshoppers, crickets, ants, beetles, cutworms & caterpillars), fruit (grapes, blackberries & cherries) or seeds (magnolia & spicebush). A rust-red crown, warm brown back & wings, & big black spots that pepper its white underparts fieldmark this small cousin to the robin.

Mates erect a nest of leaves, grass, twigs & stems on head-high limbs or "V" branches. The roost is papier-maché'd with mud or leaf mold, reinforced with rootlets & embellished with ragbits. The wood thrush lays 3-4 unpatterned, Caribbean-blue eggs. Adults winter from Mexico to Panama.

FORESTS

Coccothraustes vespertinus
Rare Winter

EVENING GROSBEAK

Drifter of the finch family, the evening grosbeak wings down the southern coast riding the crests of unseasonable cold waves. Its huge flocks migrate to coniferous forests or invade feeding stations. Snapping a sparrowy, "clee-ip," the grosbeak disintegrates cherry pits, frozen maple, dogwood & sumac seeds, or young buds with its powerful "gross" beak. By stocking your feeder full of plump sunflower seeds, you may successfully lure this bird to your homegrounds.

Look for a stout 8" finch with a bone-white or pale green, conical bill. The male has a bronzed-yellow body & eyebrows, & black wings with broad white patches. The misty-gray female shows yellow on her nape & flanks.

NOTE: THIS SPECIES IS NAMED "EVENING" GROSBEAK BECAUSE IT WAS ONCE RUMORED TO ONLY FLEE ITS NEST AT NIGHT.

Evening grosbeaks raise their families in New York, New England & Ontario on the East Coast. Balanced in the crown of spruce trees, the saucer-nest is built from small sticks knitted with rootlets, grass, bark & animal hair. The 3-4 eggs are green, splotched with light brown. Parents nurse grayish young on buds, fruits & insect larvae.

FORESTS **187**

Haemorhous purpureus
Winter

PURPLE FINCH

Imagine a typical sparrow splashed with rosé wine on its head, breast, and back. Picture this bird and you will easily recognize the male purple finch when you meet it. The brown-streaked female is key-marked by a dark jaw stripe and a white facial stripe. The 6-in. bird enlivens evergreen woods, park groves, and orchards, calling "tick" in flight between low limbs. Only the most bitter ice and snow squalls send it panhandling to your feeder. In winter this finch naturally eats tree, grass, and weed seeds. But when weather warms it hungers for sweeter fare. Peach and cherry growers blame this bird for damaging their produce by eating spring buds and green fruits.

These finches breed from the Pennsylvania Appalachians north to Canada. Males are famed romantics that fluff crests, flutter wings, and soar in song hundreds of feet aloft to woo mates. Parents build loose nests of roots, grasses, and plant fibers lined with hair in tall timber to 60 ft. high. Both incubate three to four spotted bluish eggs.

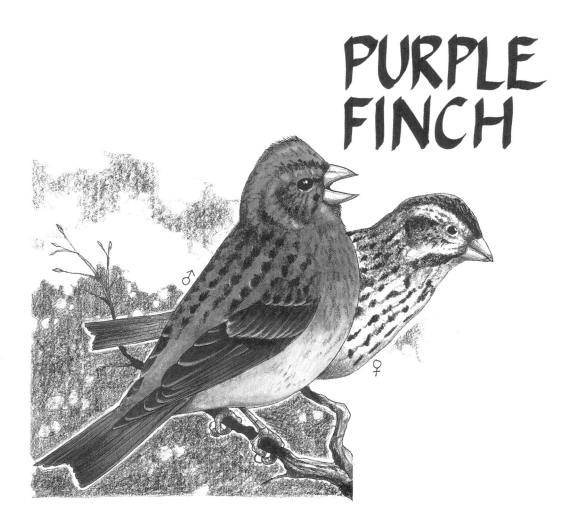

PURPLE FINCH

FORESTS 189

Spinus pinus
Winter

PINE SISKIN

A native of needle-leaved forests, the pine siskin announces its winter arrival with the buzzing call, "shreeee." The name siskin refers to the hissing sound the bird makes in flight. It roves with goldfinches in search of wind-blown seeds of pine, spruce, cedar, maple, and alder trees, and countless weeds. In warmer months, the siskin sups on insects and larvae. Its noticeably pointed, conical beak makes a deft tool for extracting these meager morsels from bark or brush. Should it come begging at your feeder, identify this finch by its heavily streaked, brown plumage. Yellow patches on the wings and sides of the tail are displayed when they are flared. Size: 4½ up to 5 in.

In eastern North America, Pine Siskins breed across Canada and the northern tier of states. They build their saucer-nests in conifers to 30 ft. above ground. The weave of twigs, bark strings, rootlets, grass, and moss is lined with thistle–dandelion down, hair, and fur. Cushioned inside are four to six pale green or blue eggs spotted brown or black.

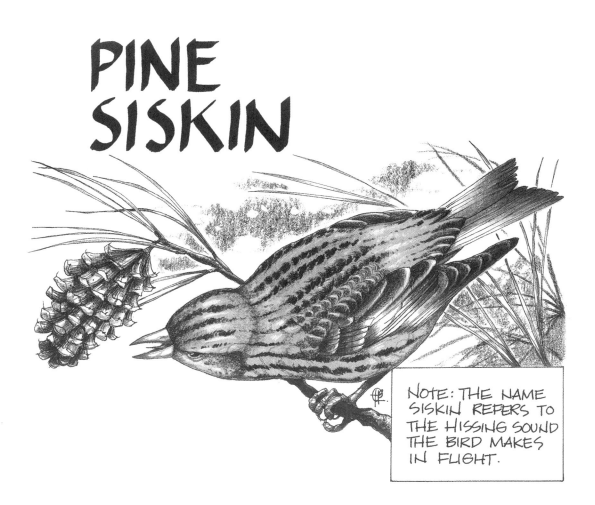

Setophaga americana
Common Summer

NORTHERN PARULA

The northern parula dwells in hammocks, swamps & mixed hardwood forests where Spanish moss festoons boughs like tattered drapery in the wind. Hunting in upper limbs, it eats spiders, caterpillars, flies, beetles, wasps, lice & scale. For its ability to hang at acrobatic angles to peck prey, it is named parula, meaning "little titmouse" (titmice perch upside down to feed). This 4½" wood warbler is blue-gray on its back. Its wings show 2 white bars. The throat & breast are yellow, & the belly is white. Males only show a chestnut chain across the neck.

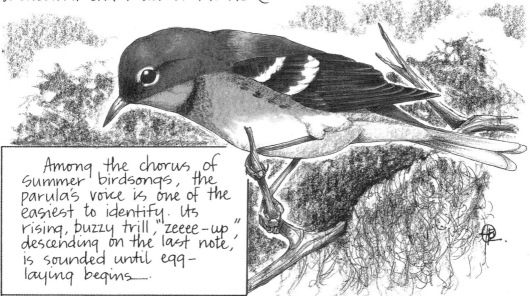

Among the chorus of summer birdsongs, the parula's voice is one of the easiest to identify. Its rising, buzzy trill, "zeeee-up," descending on the last note, is sounded until egg-laying begins.

The parula boldly burrows into bunches of Spanish moss (or Old Man's Beard lichens in the north) & lines it with fine grass, hair & thistle down to make its nest. Its 3-7 cream-white eggs are partially spotted with rust-brown. Over winter it resides from Florida to the West Indies.

Setophaga ruticilla
Common Transient

AMERICAN REDSTART

Spaniards inhabiting the West Indies name this 5" warbler Candelita, meaning "little torch" to describe the fire-orange patches on its wings & tail. The American redstart male wears black above & white on its belly, & the female is olive-white with yellow patches. This bird drops in on our deciduous forests during migrations between Caribbean Sea territories & nesting zones north of the Chesapeake Bay.

A busy-bee feeder, the redstart hops, flutters & dives after insects on foliage, bark, vines or the forest floor. For balance & maneuverability, it holds its tail fanned & its wings half-spread.

Redstarts wedge their nests in the crotches of trees. They knit a cup of grass & shredded bark, & weld the roost with plant fibers, spider webs & hair. Eggs: 3-5, white with dark spotting.

FORESTS 195

Piranga rubra
Common Summer

SUMMER TANAGER

At a passing glance, the brightly colored summer tanager (about 6½ in.) might be mistaken for a cardinal. Note these obvious field marks: the male is blood red all over, has a yellowish bill, and lacks a crest or eye mask. The female wears olive above, yellow green below.

This "summer redbird" ranges north to New Jersey to nest, April to June. As a homebuilder, this tanager cannot be called an avian architect. Its loose meshwork of grass, bark strips, stems, and Spanish moss, lodged on a horizontal limb, is so frail that the three to four spotted, aqua-blue eggs show through the walls.

Watch for the summer tanager in pine-oak woods and orchards. It inhabits upper limbs, to 60 ft. high. Caterpillars, wasps, beetles, and spiders are pecked out of foliage or caught on the wing. The bird's swollen-looking but long bill is well suited for eating both insects and fleshy fruits like blackberries, blueberries, and huckleberries. By October, summer tanagers migrate south to the Tropics (Bahamas to northern South America) to overwinter.

SUMMER TANAGER

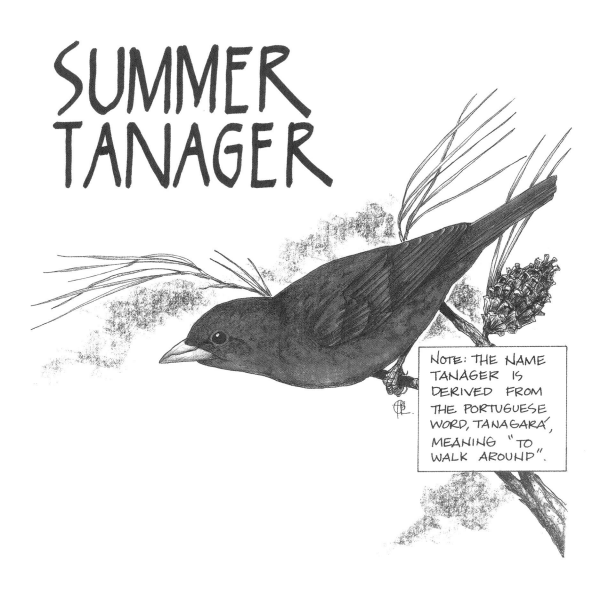

Note: The name tanager is derived from the Portuguese word, tanagará, meaning "to walk around".